IMAGES
of America

WATERTOWN
WISCONSIN: 1836–1936

W.F. Jannke III

ARCADIA

Published by Arcadia Publishing,
an imprint of Tempus Publishing, Inc.
3047 N. Lincoln Avenue, Suite 410
Chicago, IL 60657

Printed in Great Britain.

Library of Congress Catalog Card Number: 00-105510

For all general information contact Arcadia Publishing at:
Telephone 773-549-7002
Fax 773-549-7190
E-Mail sales@arcadiapublishing.com

For customer service and orders:
Toll-Free 1-888-313-2665

Visit us on the internet at http://www.arcadiaimages.com

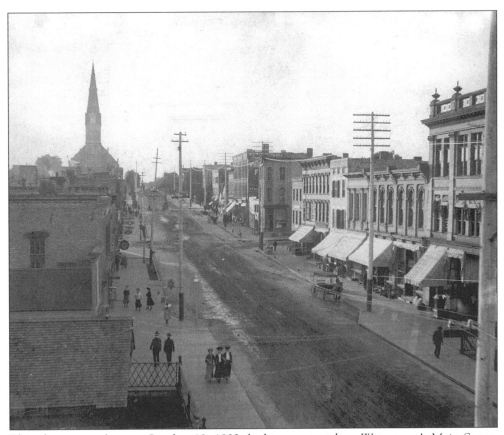

This photo was taken on October 19, 1903, looking westward on Watertown's Main Street.
(Author's Collection.)

CONTENTS

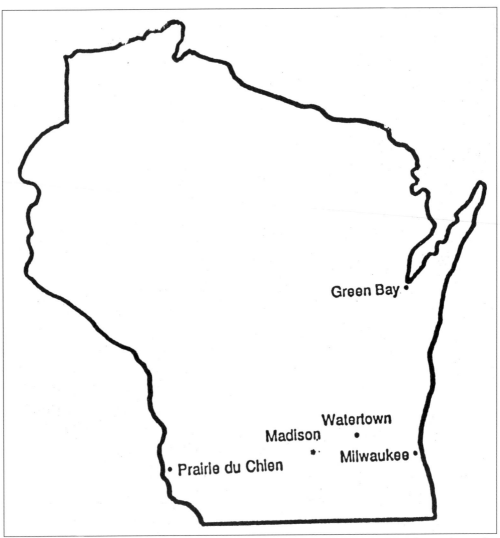

Where is Watertown located? The City of Watertown, Wisconsin, is located in the southeastern part of the state, 45 minutes travel time from Milwaukee, the state's largest city, and Madison, the state capitol.

INTRODUCTION

I have longed to tell the story of Watertown, Wisconsin, for quite some time. I love this place and its history, but it is a difficult thing to attempt to condense the history of a place you live in and love to a mere 128 pages. The text could go on and on, but that is not the scope of this work. Therefore, I decided to try to tell the story through pictures. Unfortunately, a whole slew of questions then arose—what to include, what to leave out, what are the locations of these views, etc. So I decided to simplify things by narrowing my focus to the period between 1836 and 1936, the city's first one hundred years.

Why this period? This was an exciting era, a time of growth and expansion. Businesses, many no longer represented in Watertown, began and flourished during this time period. Hundreds of people from all parts of the globe traveled here and left their unique marks on the city. So many people migrated here that by 1855, Watertown had over 8,500 residents and was considered the second largest city in Wisconsin. Now the astute reader will soon discover that there are no images from 1836 in this book. In fact, there are no images included from the time period before 1854, because photography was not invented until 1839. While there were photographers plying their trade in Watertown as early as 1847, no pictures from this period are know to survive.

Some things have been omitted, partly due to space limitations, but mostly due to a lack of photos or other pictorial representation. Undoubtedly, once this work is published many of these previously unknown images will come to light. If any readers have any photos of Watertown pertaining to anything that was not covered in this volume, please contact me. My address can be found at the back of the book. If there are enough new images, perhaps a second volume could be produced.

Watertown was founded in 1836 by Yankee settlers, who were closely followed by Irish and German immigrants, and then Bohemian and Welsh immigrants. All of these settlers contributed to Watertown's unique character. In 1839, the name of the town was changed from Johnson's Rapids to Watertown, Wisconsin, named for Watertown, New York, where many of our earliest Yankee settlers hailed from.

City growth was slow but steady. By 1844, there was a stage line routed through the town, and the first newspaper made its appearance in 1847. Also in 1847, the first brickyards opened, and large brick structures (many of which still stand in the city today) soon began to replace the wooden buildings. Watertown was granted a village charter in 1849 and became a city in 1853.

Though Watertown experienced a bit of a lull in growth and expansion in the years following the Civil War, due in part to over-extending its credit to encourage the coming of the railroad in 1855, it still continued to advance. City services such as water, electricity, and sewage were introduced in the early 1890s, and by 1900 Watertown was again on common ground with comparably-sized cities.

The twentieth century brought a plethora of new ideas and inventions. Automobiles replaced the horse, and the trolley and train competed for daily customers. Small shops expanded into large department stores, and opera houses became movie theaters. However, throughout all of this change, one constant did remain—the people. It is important to remember that fallible individuals no different than you or I made history, not demi-gods. Therefore, while history may record only the names of those who do or have done great things, it is important to remember that we are contributing to the making of history on a daily basis whether we are aware of it or not. This book pays tribute to the many individuals who have made Watertown what it is today.

To accurately and completely tell the story of Watertown, I would need a much larger

volume. It is my hope to one day write a thorough history of the city. Until that time, however, this volume will have to suffice. I hope that you, the reader, whether a long-time resident or brand-new to the city, will come to realize just what we had and what remains in order to garner new respect for the community. My family has lived and worked here since the early 1840s, and although it may not be a perfect place to live, I cannot imagine living anywhere else.

I humbly dedicate this book to the citizens of Watertown, Wisconsin—past, present, and future.

W.F. Jannke III

PROLOGUE

In 1936, the citizens of Watertown paused to look back over the first one hundred years of the city's history. The year-long celebration culminated in a series of events which took place July 3 through July 5, 1936. A grand parade featuring gaily decorated floats was held July 4, 1936.

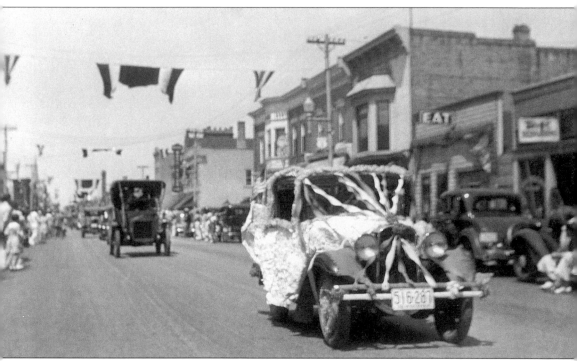

This is a scene from the 1936 Centennial Parade held July 4, 1936. (Author's Collection.)

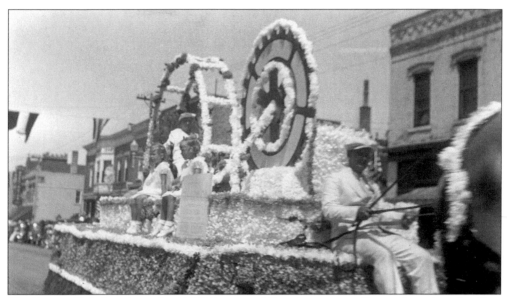

The Rotary Club float from the 1936 Centennial Parade is pictured here. Seated on this float was Mrs. Sheldon Holmes, granddaughter of the town's founder, Timothy Johnson. (Author's Collection.)

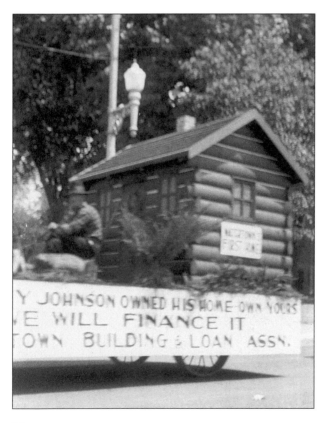

This Centennial float entry purported to show the cabin home of the pioneer settler, Timothy Johnson. (Author's Collection.)

One

PIONEER BEGINNINGS

The City of Watertown was founded in 1836. The person responsible was a Connecticut carpenter with itchy feet named Timothy Johnson. He came to the area now known as Watertown in the spring of 1836, and laid claim to the land which now encompasses the heart of the city. Johnson then went to Milwaukee to find other settlers, and by the fall there were about a dozen cabins here. The population at this time consisted of mostly bachelors.

The fledgling town grew slowly. By 1840 there was only one structure on what is now Main Street, and it wasn't until 1841 that the first retail store opened. However, by 1844 a stage line was routed through Watertown, which brought more settlers. More people required more stores, and Main Street began to flourish. More settlers also guaranteed more workers, so new industries began.

By 1853 a wooden highway, called the Watertown Plank Road, was completed. This toll road linked Milwaukee with Watertown and reduced travel time between the two cities from two weeks to one week. In September 1855, the railroad arrived, and Watertown could at last shed its pioneer status. The future lay ahead, and while there would be some pitfalls, everything at this time looked bright.

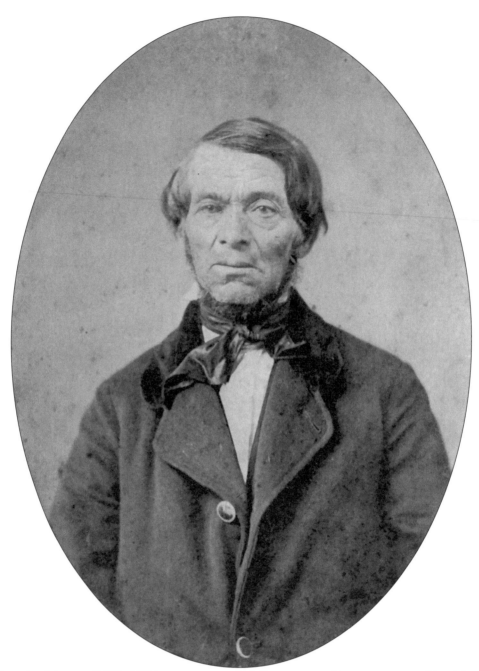

Timothy Johnson (1792–1871), was a native of Connecticut. He spent most of his life in pursuit of an ideal place to live. In 1836, he was the first to set eyes upon the site that would become Watertown. He named the area Johnson's Rapids after himself and laid claim to the land that now encompasses the city. Not content with that, however, he founded nearby Johnson Creek in 1838. In later years, he went in search of a new place to live in northern Wisconsin. He died in what later became Mendota State Mental Hospital in 1871 and lies buried in Oak Hill Cemetery in Watertown. (Watertown Historical Society Collection.)

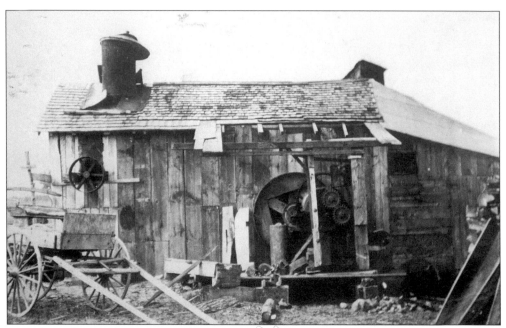

This photo depicts the William Edwards sorghum mill in about 1915. This structure was built using much of the lumber from Timothy Johnson's original log cabin. It is the closest rendition of a photo of the original cabin that currently exists. Bethesda Lutheran Home, a nationally-recognized care facility for the developmentally disabled, is located on this site today. The Edwards family were distantly related to Timothy Johnson. (Author's Collection.)

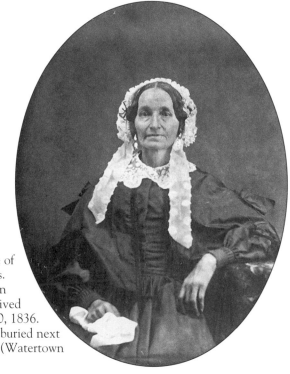

Mrs. Lucretia (Brownell) Johnson, wife of Timothy Johnson, is pictured here. Mrs. Johnson was the first woman to settle in what later became Watertown. She arrived here with her children on December 10, 1836. She died in Watertown in 1857 and is buried next to her husband in Oak Hill Cemetery. (Watertown Historical Society Collection.)

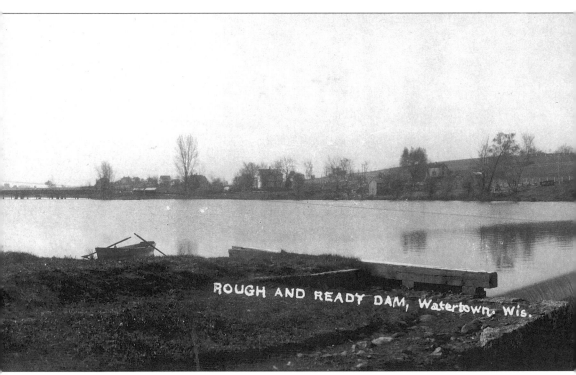

This photo, taken about 1905, shows the Rough and Ready Dam located on the east side of Watertown. The dam was originally constructed in the mid-1840s by John Richards, Luther

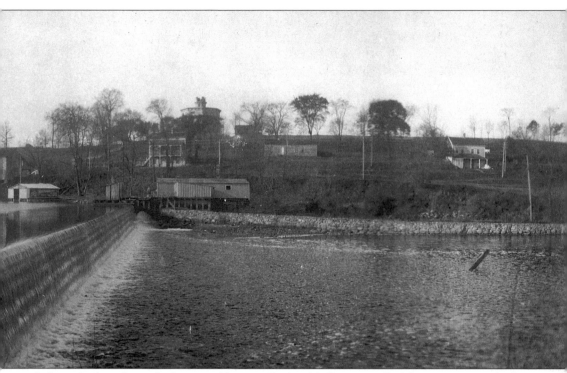

Cole, and others. It was built as an addition to Richards's flouring mill of the same name, which was destroyed by fire in the 1880s. Note the Octagon House, which is now the city museum, in the distance. (Author's Collection.)

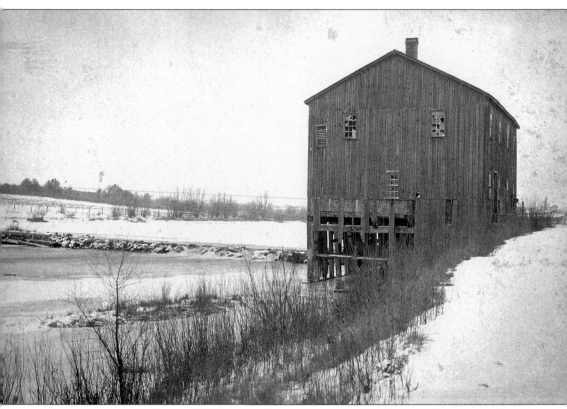

This picture depicts Boomer's Mill, named for early settler Lyman Boomer. It was one of several mills in operation in Watertown between 1837 and 1936. This particular mill was located on the west side of the city near what is now Bethesda Lutheran Home. Saw milling and grist milling were the first major industries in the city. (Watertown Historical Society Collection.)

Irish emigrants began to arrive in Watertown in the early 1840s, reaching their peak in the years following the great potato famine of 1847. This photo shows Captain James Rogan and his wife who were, by all accounts, among the very first Irish settlers in Watertown, arriving in 1837. (Author's Collection.)

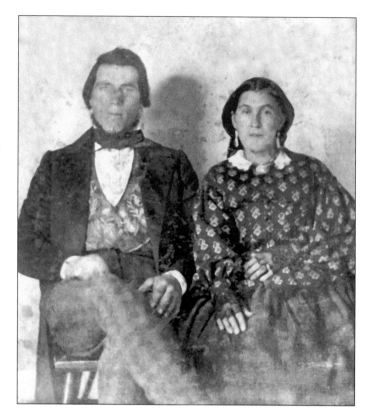

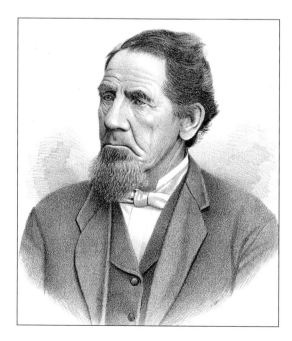

Patrick Rogan, brother of James, was also an early Irish settler. He later served a term as postmaster, was a mill owner, farmer, and also a delegate to the state constitutional convention in 1846. (Watertown Historical Society Collection.)

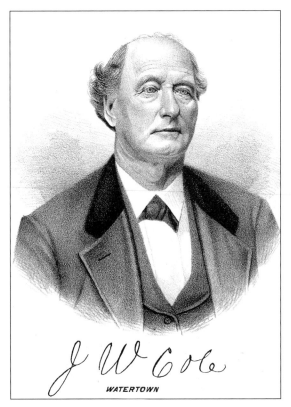

John W. Cole was among the earliest settlers and one of the great benefactors of the town. He served a term as mayor, owned substantial pieces of land, and operated several businesses. After his death he left money for many things, including a public library. (Author's Collection.)

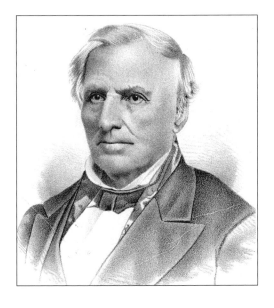

Luther A. Cole was a brother of John W. Cole. The family hailed from Vermont. Luther held several offices and was an investor in several businesses in Watertown. Together with his brother John, Luther opened the very first store in Watertown in November 1841. (Watertown Historical Society Collection.)

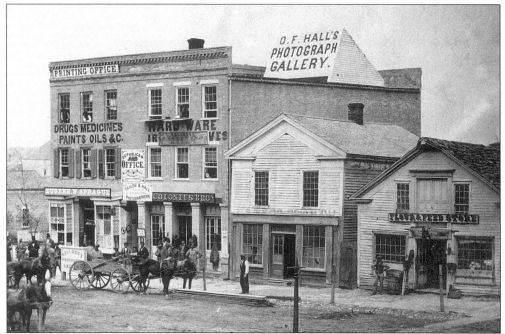

This is the corner of Main and North Second Streets in downtown Watertown as it appeared in 1866. The building on the far right belonged to John W. Cole and was built shortly after the first store opened in 1841. This is very similar to what that first store may have resembled. No pictures are known to exist of the pioneer store of Watertown, which was torn down in 1865. (Watertown Historical Society Collection.)

The first commercial structure on what is now Main Street was the Exchange Hotel, pictured here about 1860. It was built in 1840 by the Gilman Brothers and functioned as a hotel until the 1880s. In 1893, it was moved to the southeast corner of South First and Milwaukee Streets, and today is the M&M Bar. It is the oldest structure in Watertown. (Watertown Historical Society Collection.)

This is Watertown's Main Street as it appeared in 1842. No brick buildings arrived until 1847. The wife of John W. Cole, on her first sight of Watertown, recalled that, "I cannot convey...the mingled feelings of woe and disgust I entertained at my first sight of Johnson's Rapids. What

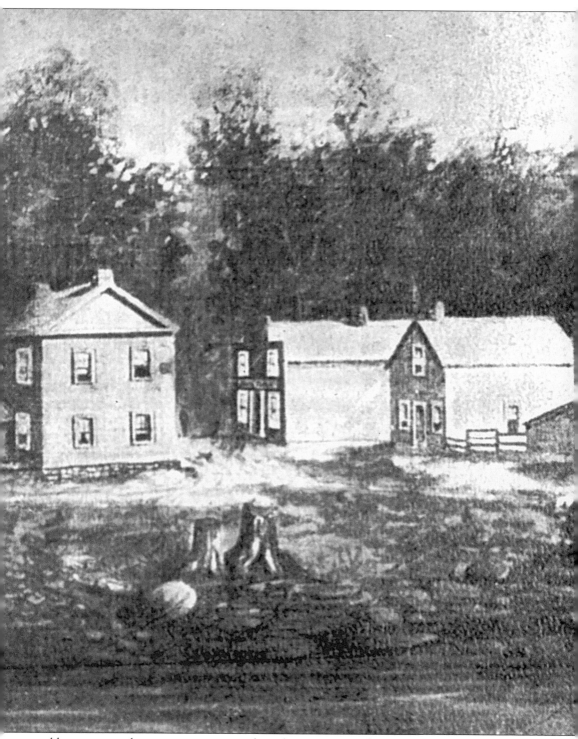

could possess people to ever come to such a place was more than I could see...." (Author's Collection.)

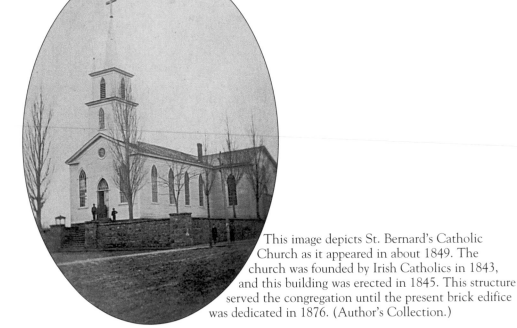

This image depicts St. Bernard's Catholic Church as it appeared in about 1849. The church was founded by Irish Catholics in 1843, and this building was erected in 1845. This structure served the congregation until the present brick edifice was dedicated in 1876. (Author's Collection.)

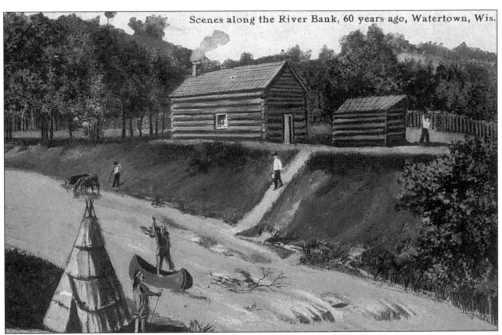

Scenes along the River Bank, 60 years ago, Watertown, Wis.

This image presents an idealized portrayal of what Watertown may have looked like by 1837. The first bridge across Main Street was not built until the 1840s, and there were, indeed, log cabins here. Frame houses did not appear until the Goodhue Sawmill began operations late in 1837, and brick homes not until 1847. (Author's Collection.)

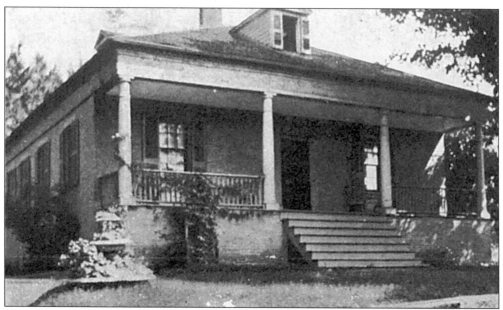

No photos are known to exist of the first brick house in Watertown. It was erected by Pliny D. Bassford in 1847. This house, built by Heber Smith for Captain Ernst Off, was among the first brick homes. It stood on the corner of Fifth and Spring Streets and fronted Fourth Street. Today the Watertown Post Office is located on this site. (Watertown Historical Society Collection.)

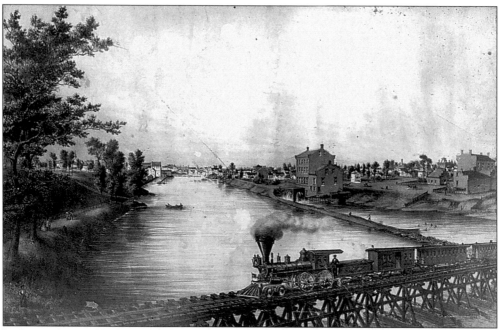

In September 1855, the first railroad entered Watertown, thus bringing to a close the pioneer days and ushering in a period of increased speed and travel. The railroad replaced the stage coach and the use of the plank road as an effective means of transporting goods and people from one place to another in a timely manner. This image dates to 1860. (Author's Collection.)

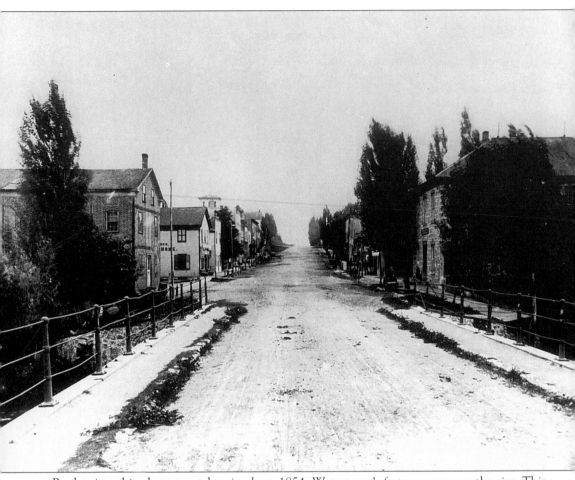

By the time this photo was taken in about 1854, Watertown's fortunes were on the rise. This image depicts Main Street looking to the west and is generally considered to be the earliest known photograph of the city. (Watertown Historical Society Collection.)

Two

INDUSTRY

When the early settlers first arrived in Watertown, they were delighted to discover the powerful force of the Rock River, which runs through the city like quicksilver. The first to utilize its power were the mill owners, who built dams and erected mill wheels to power their saws and grinding stones. Gradually more businesses began to occupy the river banks.

Slowly other industries began to originate, such as shoe-making, barrel-making, and furniture-making. When steam power began to be implemented, larger factories began to appear. The Germans brought new industries, such as brewing and cigar-making, and by the 1850s, factories in Watertown made everything from wagons to farm machinery.

It is to Watertown's credit that it has never relied on one major industry to carry the city's fortunes. There has always been a rich diversity of industry here, so much so that when one type of business would fold, another industry would be able to step in to fill the void.

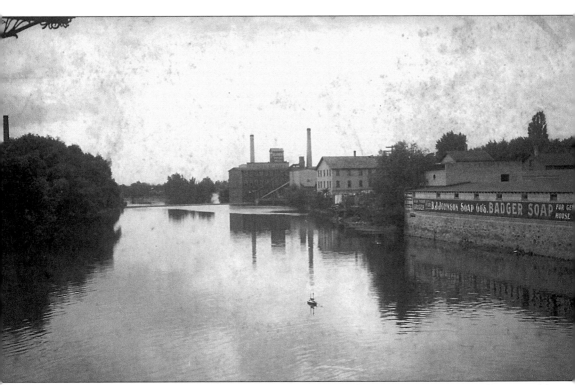

Most of the earliest industries were located along the Rock River in Watertown. The powerful stream was harnessed to turn the wheels of commerce. By the time this photo was taken in about 1895, most businesses no longer relied on the river to power their machinery. (Author's Collection.)

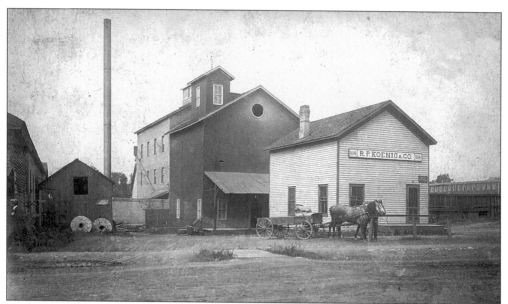

The R.P. Koenig Mill was located on South First Street in Watertown. It was a flouring mill in operation from the late 1870s until 1921 when it was purchased by A.C. Jaeger, who maintained it until the 1950s. Today the Watertown Senior Center is located on this site. (Author's Collection.)

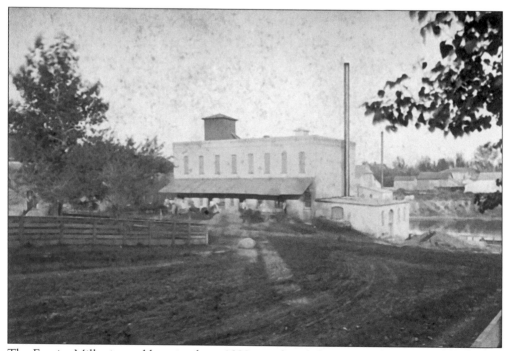

The Empire Mill, pictured here in about 1880, was founded in 1848. The original mill burned down in 1871 and was rebuilt. In 1891, this mill became the Globe Mill, which was in operation through the 1980s. (Author's Collection.)

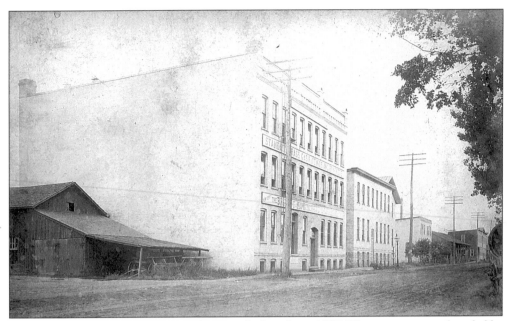

This is the Brandt-Dent Company, photographed in about 1897. The company was founded by Edward J. Brandt and Robert Dent. and originally made brass light fixtures. This building was erected in 1893. In 1896, Brandt invented the automatic cashier. The factory, which was located on South First Street, was demolished many years ago. (Author's Collection.)

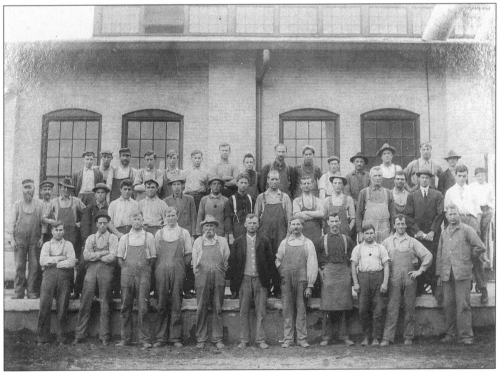

The employees of the Brandt-Dent Company are pictured here around 1915. William Jannke, the author's grandfather, is visible in the front row, third from left. (Author's Collection.)

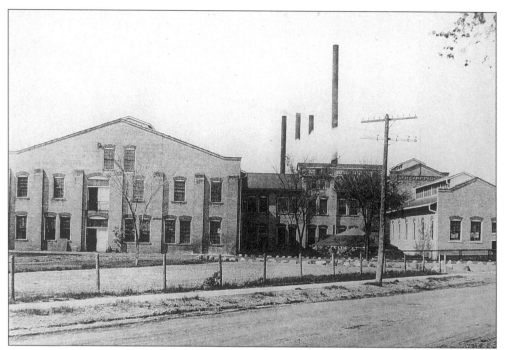

The Van Camp Milk Condensory Company is shown here in a photo taken by William Streblow on May 16, 1921. Farmers from all surrounding areas would bring their milk to the plant to be processed. Today it is the site of Karma, Inc., a firm that makes—among other things—vending machines. (Hildebrandt Collection.)

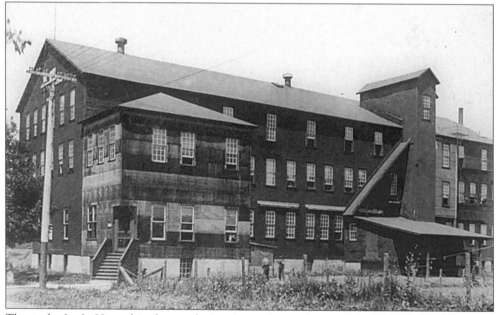

This is the Ira L. Henry box factory depicted in a photo taken on July 19, 1920. This company opened its doors in Watertown in 1900. The original plant, shown here, burned to the ground in 1945. It was replaced by a substantial brick building and is still in operation today. (Hildebrandt Collection.)

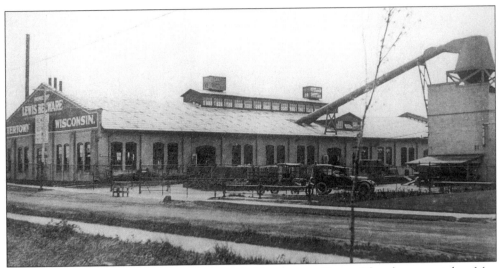

This is the G.B. Lewis Plant, located on South Montgomery Street. The photo was taken May 16, 1921. Originally located along the Rock River, the plant manufactured boxes and other wood products until 1909. In that year, a disastrous fire wiped out the plant, and they relocated inland. In the 1920s, they experimented with new forms of box construction and made toys. Later, they made fiberglass storage boxes and crates. The factory is currently known as Applied Molded Products Corporation. (Hildebrandt Collection.)

This is the Beals and Pratt Shoe Company in a photo taken on May 16, 1921. Originally built in 1904 as the Beals and Torrey Shoe Company, it operated as a shoe factory for many years. In the late 1920s, this building became the Kusel Dairy Equipment Company, and today it is an apartment building called Riverview Terrace. (Hildebrandt Collection.)

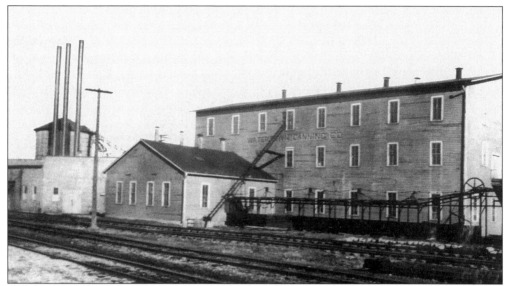

The Watertown Canning Factory is pictured here in a photo taken about 1921. The canning factory was established in 1912 primarily to can peas. The factory was located on the northwest side of the city near the railroad tracks and closed in the late 1950s. The factory buildings were demolished in the early 1990s. (Hildebrandt Collection.)

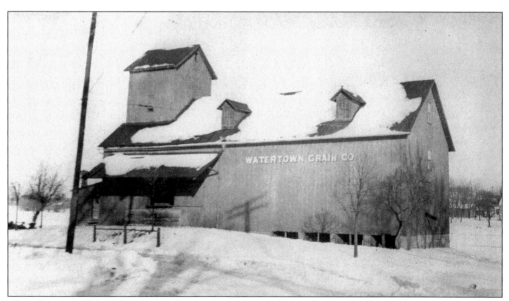

The elevator of the Watertown Grain Company is shown here in a photo taken on January 24, 1927. This building was originally located at the foot of West Main Street near the C & NW Depot, but was moved intact to a site along North Water Street at the foot of Rock Street. Today this is the site of Fannie P. Lewis Park. (Hildebrandt Collection.)

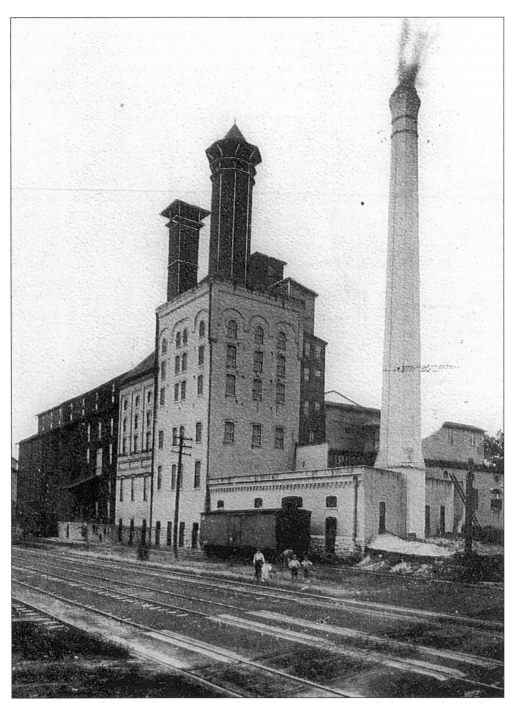

The William Buchheit Malting Company, located at 110 South Ninth Street in the southern part of the city, is visible here in a photo dated c. 1910. The malting company began in 1888 and was also known as the American Malting Company and Fleischmann Malting Company. Still later it was known as Old Elm Mills. The company suffered two major fires in 1946 and 1959, and only part of the complex exists today. It is now the home of Y's Way Carpeting. (Lindemann Collection.)

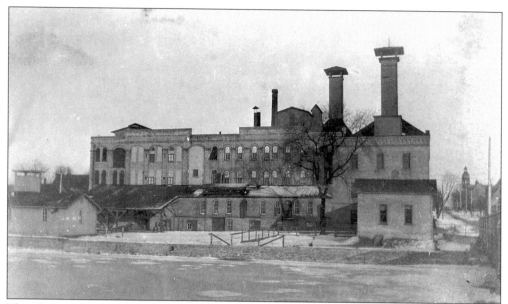

The William Hartig Brewery, seen here in the late 1910s, was the major brewery here from 1884 until it closed in 1947. The brewery was located at 100 Cady Street and was originally founded by Jacob Hoeffner in 1847. It was purchased by William Hartig and Carl Manz in 1884. Today a supermarket is located on this site. (Author's Collection.)

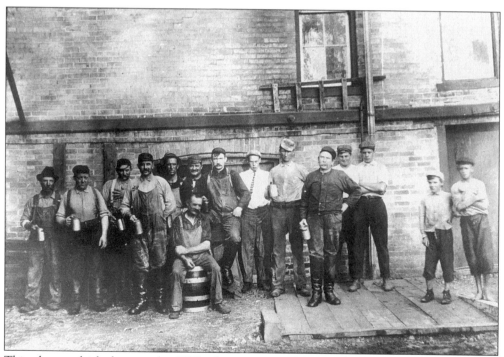

This photo, which dates to the 1890s, depicts some of the employees of the Hartig Brewery. (Watertown Historical Society Collection.)

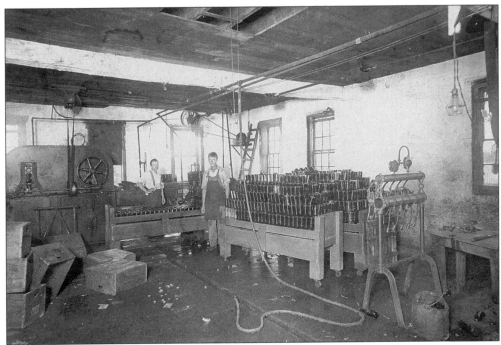

This is a rare photo of the bottling plant of the Hartig Brewery, c. 1900. The trademark of the Hartig Brewery was a lion, which was featured on most of its advertising and represented as a large weather vane on top of the brewery. (Author's Collection.)

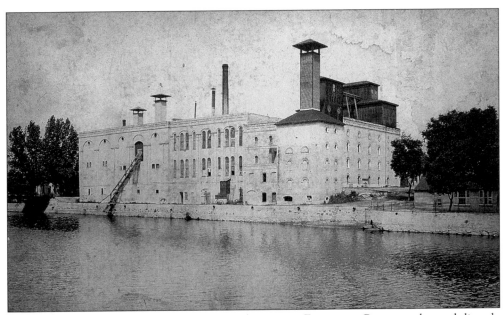

The other major brewery in Watertown was the August Fuermann Company, located directly across the street from the Hartig Company. It was in existence from 1848 to 1898, when it was purchased by the Hartig Brewery. Today this is the site of the city's municipal building. (Author's Collection.)

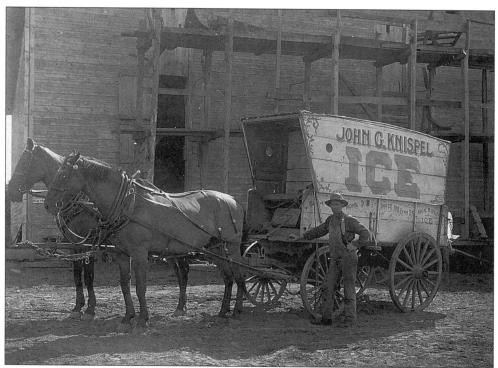

John Knispel was the ice man in Watertown for many years. He took over the business from S.M. Eaton in 1909, in partnership with the Kolhoff Brothers. John Knispel and his sons delivered ice door-to-door for many years in Watertown—all the way until the 1940s. (Author's Collection.)

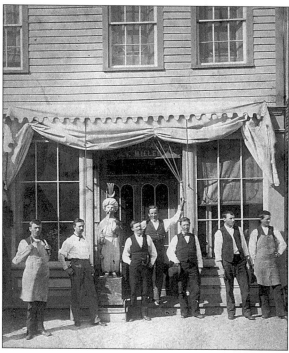

The German immigrants brought many new industries, such as cigar-making. The Adolph Miller Cigar Factory is pictured here in an image which dates to 1881. Note the cigar store Turk, which still exists in the collection of the Watertown Historical Society. The Miller Company was located on the corner of Main and Fourth Streets and closed in the 1930s. (Author's Collection.)

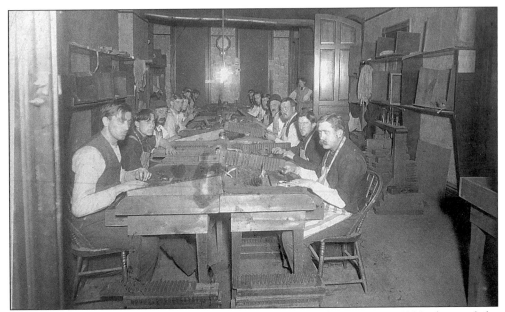

The cigars in Watertown were all hand-rolled, as shown here in a c. 1900 photo of the Neumann & Krueger Cigar Factory workers. In 1880, Watertown cigar makers turned out 2 million cigars per year. There were many cigar factories in Watertown, and tobacco was processed here up to the 1960s. (Author's Collection.)

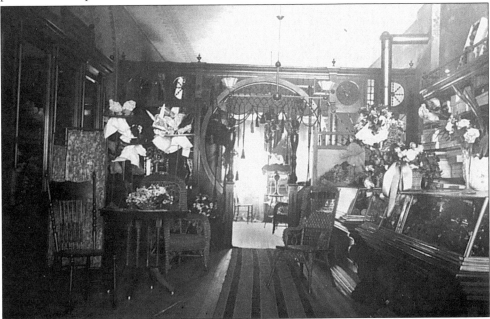

This photo depicts the interior of the Clara Weiss millinery shop, which was located on Main Street, c. 1890. Today this building is part of the WTTN Radio building. Mrs. Weiss was one of many ladies who produced fashions for the women of Watertown. Her shop closed in the 1920s. She and another lady milliner, both divorced from their husbands, used to regularly throw lavish parties on the anniversaries of their divorces. (Watertown Historical Society Collection.)

The ladies of Mrs. Catherine Buechele's Millinery Shop are pictured here showing off their finest chapeaux for spring, c. 1900. Her shop was located at 509 Main Street. (Watertown Historical Society Collection.)

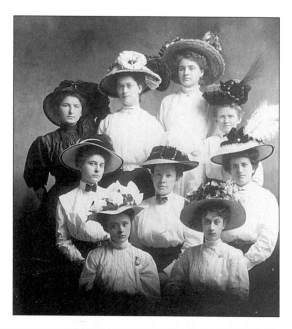

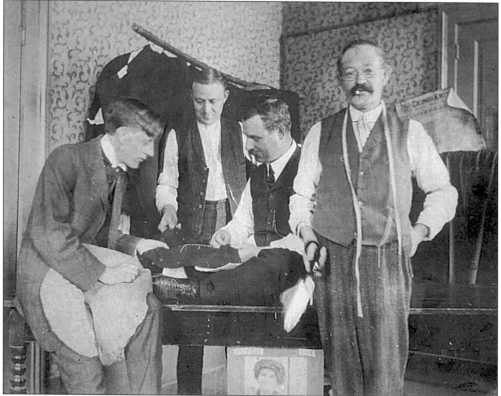

Just as the ladies had their millinery stores, so, too, did the men have their tailoring and haberdashery establishments. In this picture, which dates to 1894, Fred Faber, Henry Korn, Ed Seefeldt, and Osmon Schmidt can be seen attending to the business of creating a custom-made suit. (Watertown Historical Society Collection.)

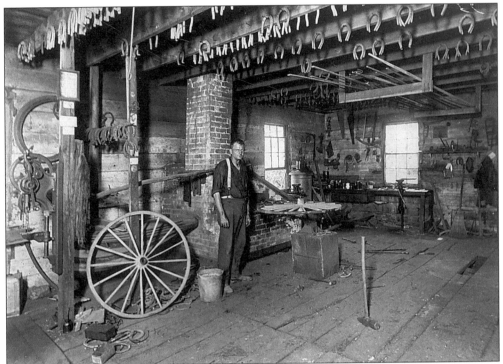

This is the interior of the August Kramp Company, which was a blacksmith and farm machinery plant on East Main Street for over one hundred years. The shop later became a car dealership but also did a small blacksmith trade on the side for many years. The Kramp Company closed in the mid-1980s. (Author's Collection.)

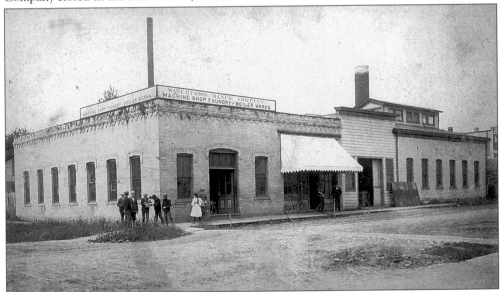

This is one of the many factories in Watertown in the latter half of the nineteenth century. This factory is the Watertown Manufacturing Company, located on the corner of South Fifth and Market Streets. This photo dates to about 1895. This company made boilers, among other things. (Author's Collection.)

The William C. Raue Paint Store, pictured here in July 1888, was founded by William C. Raue in about 1884. It was an interior decorating establishment which employed 20 men. The store was located at 309 Main Street and today is part of Busse's Pharmacy. (Watertown Historical Society Collection.)

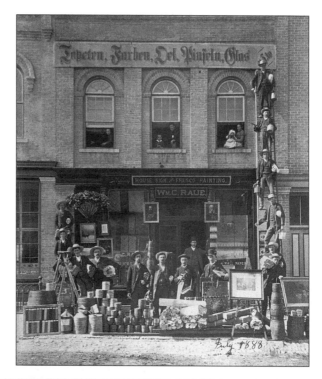

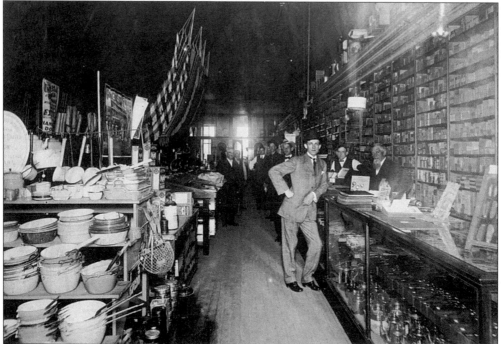

The pioneer hardware store in Watertown was the Kusel Company, founded in 1849 by Daniel Kusel. This photo, which dates to 1890, shows the interior of their store which was a landmark on Main Street for well over one hundred years. Daniel Kusel Jr., son of the founder, is visible behind the counter on the far right. (Author's Collection.)

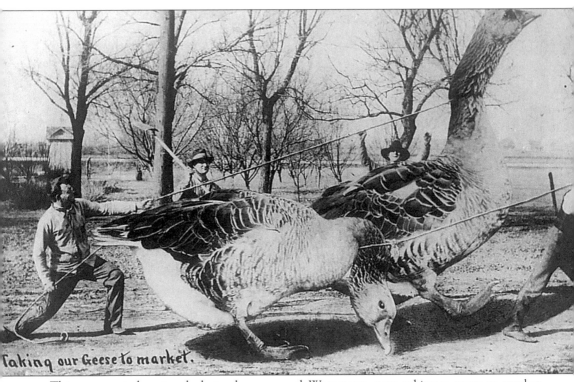

Taking our Geese to market.

This exaggerated postcard photo shows several Watertown men taking a goose to market. Watertown was known for its succulent stuffed or noodled geese from the 1850s through the early 1970s. Farmers would force-feed their geese thick noodles to increase the size of their livers. The livers of these geese were considered very tasty and were served in fancy restaurants throughout the country. The industry was so important that the local sports teams in town are called the Goslings in homage to this once famous industry. (Author's Collection.)

Three

CHURCHES AND SCHOOLS

Spiritual well-being and education were of the utmost importance to the early settlers of Watertown. The first school was organized as early as 1839. This school was taught by Miss Dolly Piper and was so small that when dancing was taught, according to one story, the boys would have to step outside while the girls turned around. The first school board was organized in 1844, and by the 1850s a uniform system of education, known as the Union School System, was in place. Other innovations in education that originated in Watertown included the founding of the first Kindergarten in America in 1856 by Margaretha Meyer Schurz, and the first free textbook program in the state of Wisconsin in 1876.

The first religious services were held in 1837 in the home of Timothy Johnson, the founding settler. This was a Methodist service. In 1843, the first Catholic Mass was held in the Crangle home, and later this small group of Irish Catholics formed St. Bernard's Catholic Church in 1845. Other early churches included the Congregational Church in 1845, St. Paul's Episcopal Church in 1849, and St. Luke's Church, which began as a Free church in 1847. St. John's and St. Mark's, the first Lutheran churches, began in 1852 and 1854 respectively, and a German Catholic Church, St. Henry's, began holding services in 1853.

Other churches in Watertown founded prior to 1936 were the Reformed Church, the Church of Christian Science, Immanuel Lutheran Church, the Advent Church, Wesley Methodist Church, Seventh Day Adventist Church, Trinity Lutheran Church, Moravian Church, First Baptist Church, and Welsh Congregational Church. Of these churches, only the Reformed, Christian Science, Wesley Methodist, and Welsh Congregational Churches are no longer in existence.

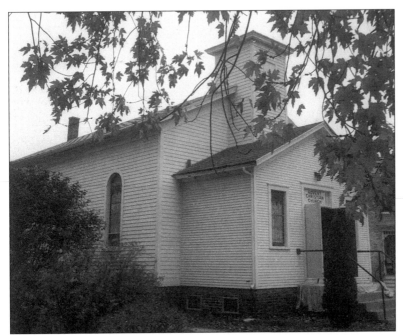

The Advent Church is located on South Eighth Street. This congregation was founded in 1872, and the church was built in 1873. It is a small congregation but one with many loyal souls. (Watertown Historical Society Collection.)

The Welsh Congregational Church, pictured here, flourished in the 1860s. It was located at 300 North Washington Street and closed in 1930. It was in this church that Rahel O'Fon, a female minister, preached the Word of the Gospel. She later became the wife of a local wagon maker named Edward Davies and was the mother of Joseph E. Davies, who was the Ambassador to Russia under Franklin Delano Roosevelt. (Author's Collection.)

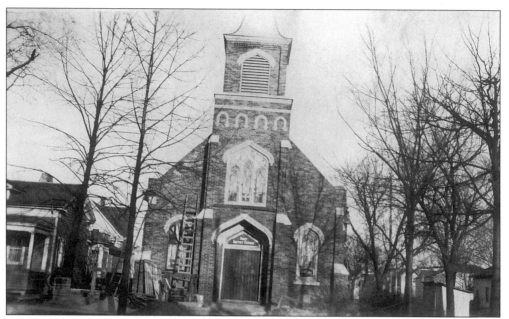

The First Baptist Church was founded in the year 1849 in Lebanon, just north of Watertown. The church set up a mission congregation in Watertown in 1854. This picture, taken about 1927, shows the church building on South Fifth Street, which was constructed in 1926. Today a Pentecostal church known as the Apostolic Gospel Lighthouse meets in this building. (Author's Collection.)

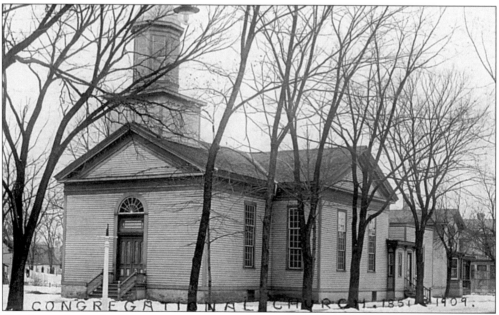

This image shows the Congregational Church, known as the "tin top" church because of its tin roof, about 1900. This building, which was erected in 1850, was located on Wisconsin Street. It was replaced by a substantial brick church in 1909. At that time this building was moved to its present location at the corner of Milwaukee and South Second Streets. (Author's Collection.)

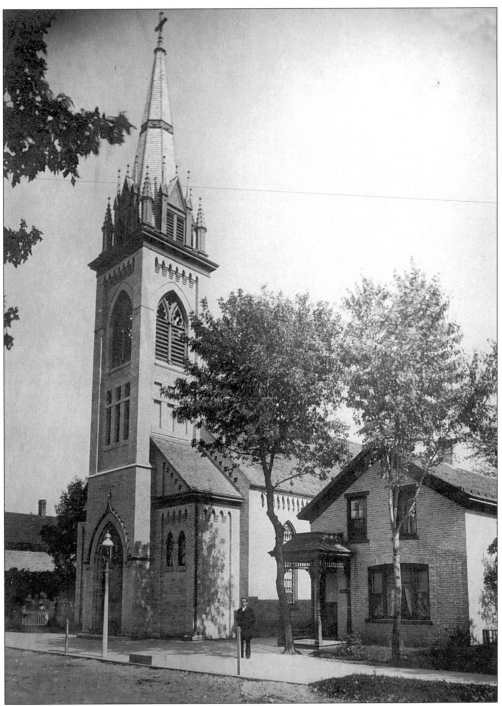

Immanuel Lutheran Church began in 1875 as a result of a dispute with St. Mark's Lutheran Church. The minister, Rev. Heinrichs, was fired by St. Mark's, and he and some of his followers founded a rival congregation. This photo, taken about 1900, shows the old church building. This building, erected in 1876, was demolished in 1953, and a new Lannon-stone church was erected. (Schroeder Collection.)

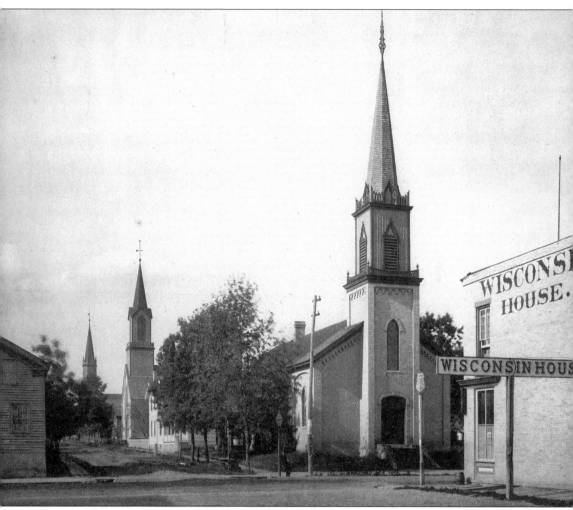

This view of Main and Fifth Streets in 1887 shows the Methodist Church and the Wesley Methodist, also known as the German Methodist Church, in the distance. The Methodist Church was the first religious body here, with services held in private homes as early as 1837. The Wesley Methodist Church and the Reformed Church merged with the Methodist Church in the late 1960s, and in 1970 the congregation built a new church located on Hall Street known as Christ United Methodist Church. (Author's Collection.)

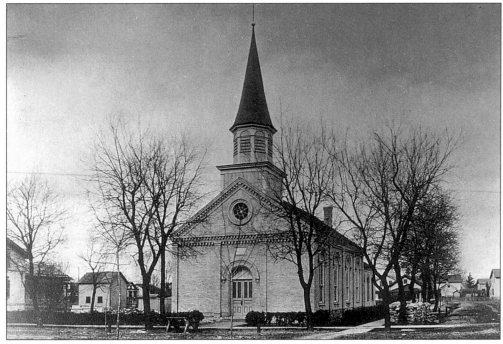

The Moravian Church, located on Cole Street, was founded in Watertown in 1853. The mother church was Ebenezer Moravian Church, which is still active. The Watertown branch began in 1855, and a church was erected in 1864. This photo shows the church as it looked in about 1900. In 1904, a new church was built, which is still in use. (Watertown Historical Society Collection.)

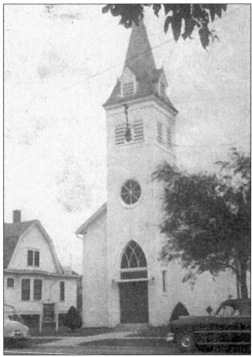

The Zoar Reformed Church was located at 412 Cole Street. It was founded by Germans in 1861, who built a church in 1862. In 1933, the congregation changed its name to the First Reformed Church, and it merged with the Methodist Church in the early 1960s. This building has since been demolished. (Watertown Historical Society Collection.)

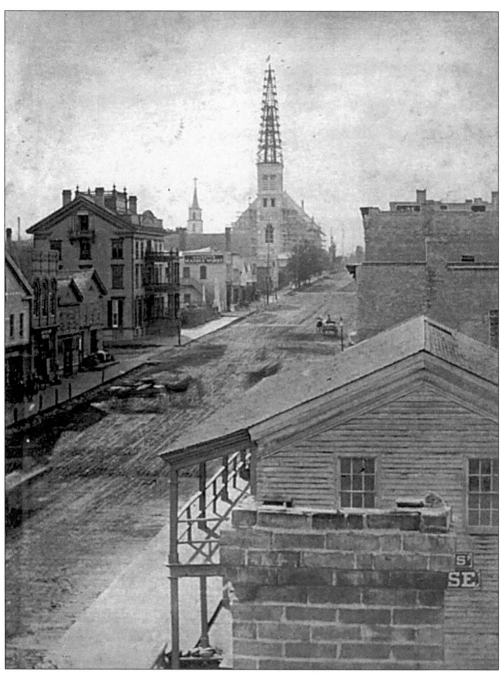

This photo, dated about 1873, depicts the construction of St. Bernard's Catholic Church. The cornerstone of the church was cut from the famous Rock of Cashel in Ireland. The church was finished and dedicated in 1876. Note the wooden building just to the left of the church. This was the original church building, which was demolished shortly after the completion of the brick church. (Author's Collection.)

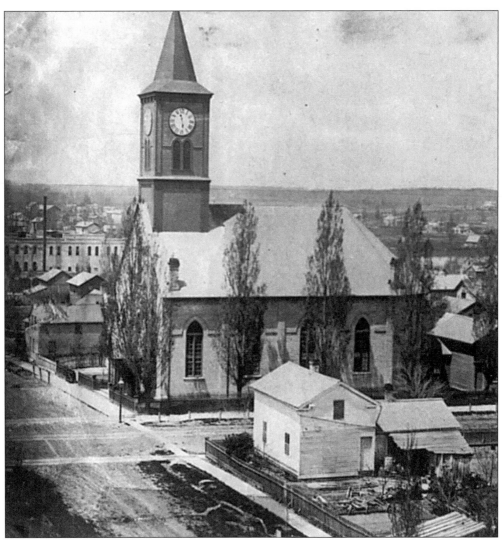

St. Henry's Catholic Church is shown here in an image taken about 1870. This was the German Catholic Church, which was sometimes known as the Bohemian Church for the many immigrant Bohemian families who attended services here. The clock in the steeple was the first public clock in Watertown, and for many years the city actually paid the church to maintain the clock. (Watertown Historical Society Collection.)

This extraordinary photo shows the demolition of St. John's Lutheran Church in 1907. It was captured by Mr. R. Grossnick at the very moment the church steeple fell to the ground. (Author's Collection.)

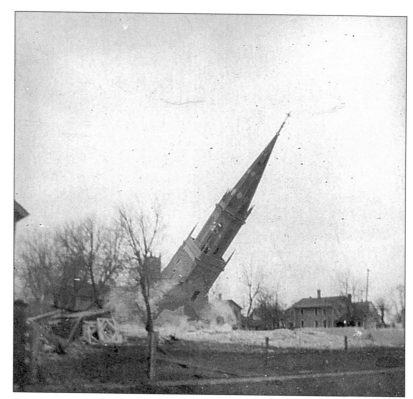

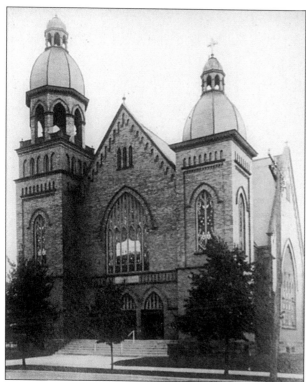

St. John's Lutheran Church is depicted here as it appeared on August 9, 1920. This church was founded in 1852 with a Gothic-style building from 1865 to 1907. In 1908, the present church building (pictured here) was erected. (Hildebrandt Collection.)

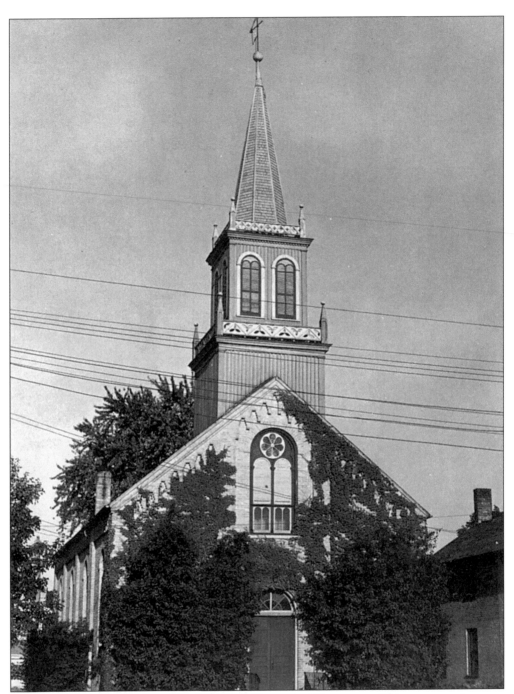

St. Luke's Church stood on North Fourth Street in Watertown. This congregation was established in 1847 by a group of German free-thinkers, and it had no formal affiliation with an organized religious body until it became a Lutheran church in 1909. This building was erected in 1865 and served the congregation until 1960, when a new church was built on Clark Street in the southern part of the city. This building has since been demolished. (Watertown Historical Society Collection.)

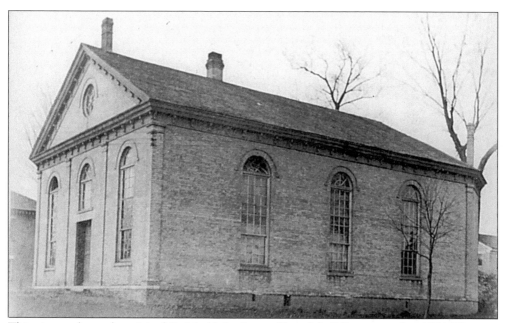

This picture shows the original St. Mark's Lutheran Church building, erected in 1854. This was the first brick church building in Jefferson County, and it served as the meeting place for the congregation until a new, larger church edifice was erected in 1888. This building, located on Jones Street, later served as the St. Mark's parish hall and ultimately was demolished in the late 1980s to make way for a new parish hall attached to the church. This photo was taken on May 12, 1918. (Hildebrandt Collection.)

The new St. Mark's Church was completed in 1888. This photo shows the structure which, with a few exceptions, has remained unchanged since that time. Recently the church underwent an extensive interior remodeling project, correcting and restoring its internal fixtures and bringing back styles hidden since the early days of the church. This photo was taken on May 20, 1918. (Hildebrandt Collection.)

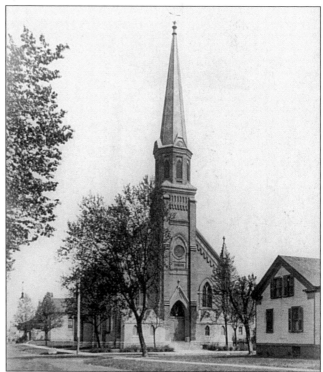

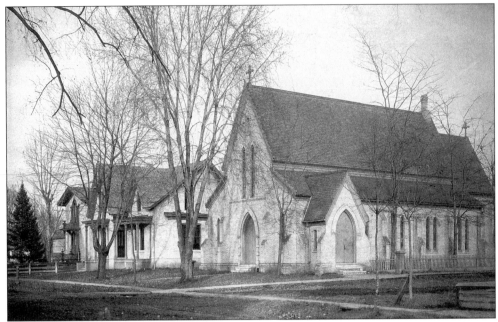

St. Paul's Episcopal Church has the distinction of having the oldest church building in the city. The congregation was organized in 1845, and the building was erected in 1859. This picture dates to 1887. (Author's Collection.)

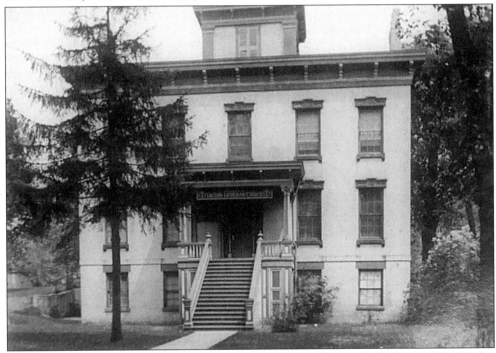

Trinity Lutheran Church was founded in 1917 by members of St. Mark's Lutheran Church who wished to hold services in English rather than German. It first met in a private home originally owned by Luther Cole and later by William Buchheit. This building was demolished in 1952 to make way for a new Lannon stone church building. (Hildebrandt Collection.)

This is the very first high school in Watertown. It was originally the home of C.M. Ducasse and was sold to Theodore Bernhard for use as a private school. In 1860, it became the public high school, and it later served as a kindergarten run by "Tante" Ella Koenig. The building stood on the corner of Fifth and Jones Streets and was demolished in the late 1930s. (Author's Collection.)

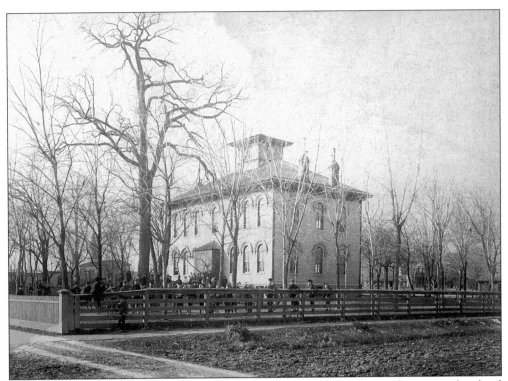

The building pictured here is the third high school—the second was turned into a grade school in 1897. This building served as the city's high school from 1897 to 1917, and later it served as the armory and as a youth activity center. It was demolished in the late 1960s, and a large hotel was constructed on its site in the early 1970s. Today it is the site of the Heritage Inn. (Author's Collection.)

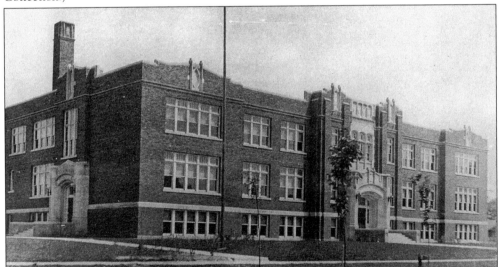

This is the Watertown Senior High School, located on Eight Street. This building is what most people in Watertown recognize as the high school. It served as the city's fourth high school building from 1917 to 1994, and was demolished in 1999–2000. This photo was taken May 20, 1918. (Hildebrandt Collection.)

54

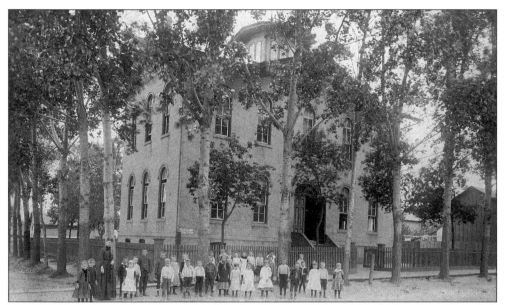

Union School No. 3, or Douglas School, is depicted here in 1896. This school was located at 505 Lincoln Street and was built in 1871. It was named for Stephen A. Douglas, the "Little Giant" who ran unsuccessfully against Lincoln for the presidency in 1860. This building was demolished in the 1990s. (Watertown Historical Society Collection.)

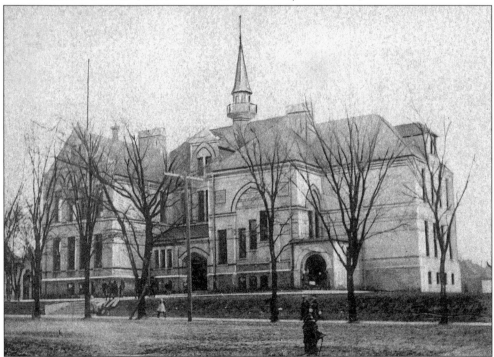

Union School No. Four is pictured here. It was built in 1881 and initially used as the high school. In 1897, it became a grade school known as Webster School, named for great orator Daniel Webster. It was demolished in the late 1950s to allow for the present Trinity-St. Luke's School on Western Avenue. This photo dates to about 1916. (Author's Collection.)

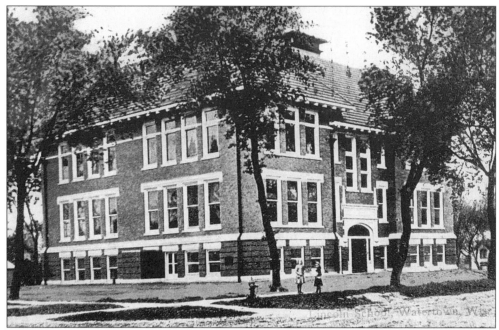

Union School No. Two was built in 1867 and rebuilt in 1910 as Lincoln School, which is pictured here. It is located on the west side of the city, on Montgomery Street. In 1946, this building burned down, and a new school was erected and dedicated in 1949. The author of this book and his father were both proud alumni of Lincoln School. (Author's Collection.)

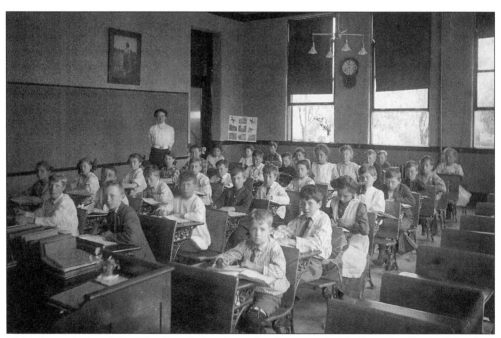

This photo depicts Miss Elsa Rose's fourth grade classroom inside Lincoln Grade School, c. 1912. This school was named for President Lincoln in 1909, in honor of the centenary of his birth. (Author's Collection.)

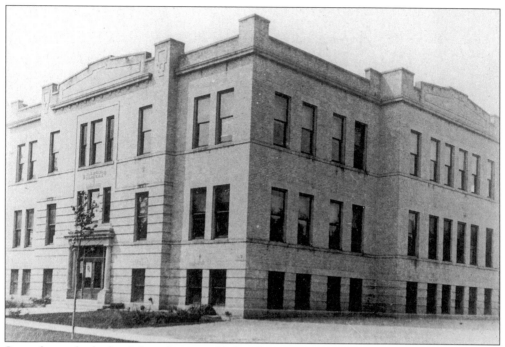

Several parochial schools have been established here as well. One of these is St. Mark's School. This picture shows the old school on Jones Street, May 20, 1918. The first school was established in the 1850s, and this building was built in 1914. It was demolished in 1974 to make way for a modern school building. (Hildebrandt Collection.)

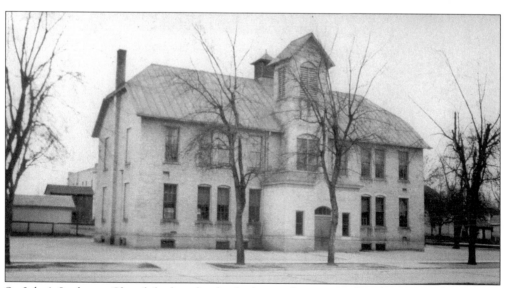

St. John's Lutheran Church had a school, which was also organized in the 1850s. This picture, taken on August 9, 1920, shows the original school which was built in 1885 and demolished in 1956 in order to make way for a larger, more modern school building. (Hildebrandt Collection.)

July 4 — 06.

Watertown has also had two private colleges in its extensive history. This photo depicts the College of Our Lady of the Sacred Heart, which was founded in 1872. Originally a regular Catholic college, the school later operated as a normal school for the Brothers of the Holy Cross. It then served as a high school seminary until 1955, when it became a Catholic military school. It operated as such until the facility was sold to the Baptist church in 1968. The facility is now known as Maranatha Baptist Bible College. (Lindemann Collection.)

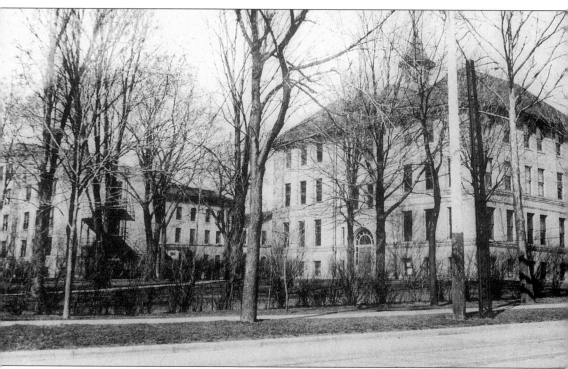

The other private college was Northwestern College, which was founded in 1863 as a Lutheran college and preparatory school. It also offered high school courses to prepare students for the seminary and college work. In 1994, Northwestern moved the campus to New Ulm, Minnesota, and the college ceased to exist. The former college is currently the site of the Martin Luther Preparatory School, a Lutheran high school. (Hildebrandt Collection.)

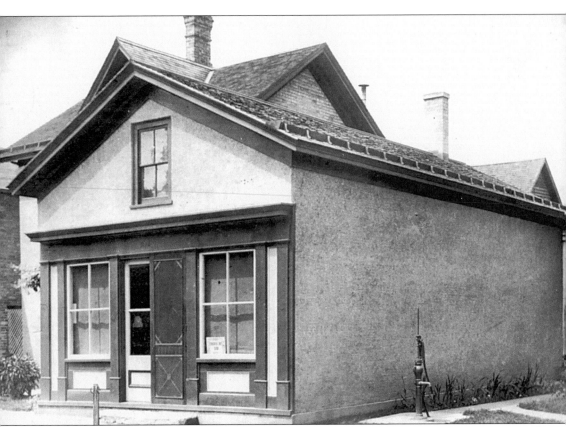

This picture, which dates to 1927, depicts the first Kindergarten in America in its original location at the corner of North Second and Jones Streets. The original was believed to be a frame structure. The building served other purposes after the Kindergarten, and it was remodeled and expanded, hence the changes apparent in this image as compared with the restoration of the Kindergarten, which can be toured on the ground of the Octagon House museum today. The Kindergarten was founded by Margaretha Meyer Schurz in 1856 and was maintained by her for about two years. (Author's Collection.)

Four

HOMES FOR ALL

The first thing a pioneer had to do was erect shelter, either for himself or his family. Timothy Johnson built a lean-to shanty that was shared by his family and several men working on a mill in 1836. In the spring of 1837, he moved his family into more spacious quarters. John and Luther Cole, along with Amasa Hyland, lived a bachelor's lifestyle in a little cabin located north of town. They made it a habit not to wash dishes until they could count the mouse tracks on them. This was the situation in the 1830s and early 1840s.

When the brickyards opened in 1847 and fortunes improved, the early settlers quickly rid themselves of their humble beginnings and tried to outdo each other by building beautiful homes. There is a rather apocryphal story that concerns John Cole, Patrick Rogan, and John Richards, all early Watertown residents. It was the 1850s, and they had a contest to see who could build the finest house in the city, a house that would make anyone who saw it stop and say, "Someone important must live there!" So John Cole and Patrick Rogan each set out to build beautiful Italianate mansions. However, John Richards owned a hill, and he decided to do things differently. Richards built an octagon-shaped house to take advantage of the light and air. Each house still stands, but while the Cole and Rogan homes have long been admired, it is the Richards home that inspires the awe-struck looks, and people have often remarked, "Someone important must have lived there." So who is the victor?

Though many of the homes in Watertown still exist, even more do not. The old homes that still survive, in some cases, suffer from bad remodeling, modernizing, and inappropriate additions or subtractions. Because of the tremendous costs of maintaining such homes, many have been cut into apartment houses. However, pockets of historic homes such as those in the North and South Washington Street area on Clyman Street, still reflect a feeling of the genteel days of Watertown's past.

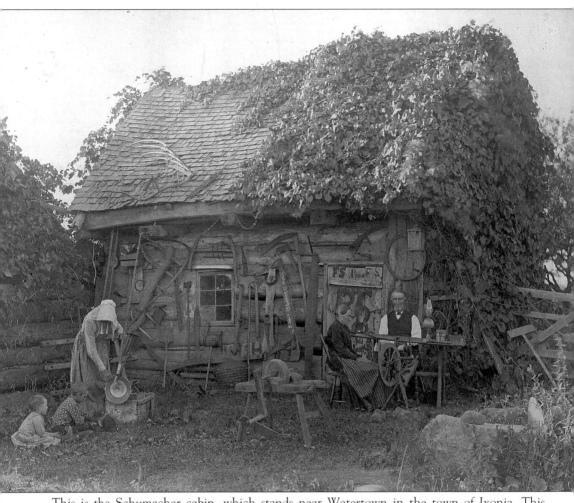

This is the Schumacher cabin, which stands near Watertown in the town of Ixonia. This picture, taken in the late 1880s, gives a fairly clear representation of the living quarters of our earliest settlers. Incidentally, this heavily remodeled cabin still stands. (Watertown Historical Society Collection.)

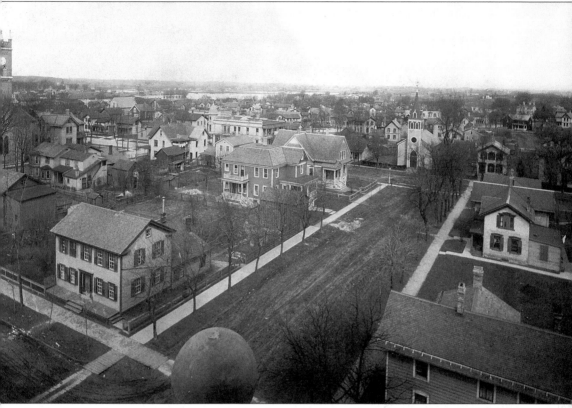

By the 1850s, frame and brick houses had replaced the log cabins of the 1830s and '40s. This photo shows a bird's-eye view of a residential district of Watertown, in the North Fourth and North Fifth Street areas. Many of the homes pictured here still stand. (Watertown Historical Society Collection.)

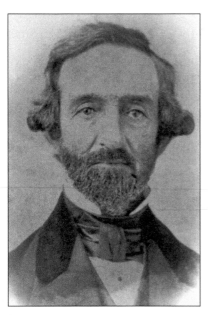

The early settlers started began their lives in Watertown in humble dwellings. This is William M. Dennis, the first postmaster and later mayor of Watertown. He began his residence here in 1837 in a modest home. By the 1850s, however, he had made his fortunes in land and other businesses and managed to construct a beautiful mansion. (Author's Collection.)

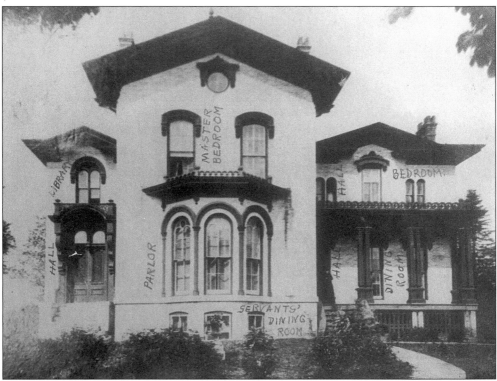

This is the William Dennis home, located along Montgomery Street. (The writing on the photo was done by a former resident of the home.) Like most prominent businessmen, William Dennis took pride in his home and wanted everyone to see how important and well-off he was by building a large mansion. This house no longer exists. In fact, the only thing remaining is the carriage house, which was used as an illegal brewery during prohibition. (Mary Mueller Collection.)

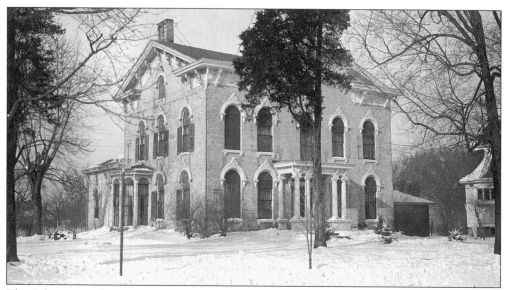

The John W. Cole home at 802 North Fourth Street was built in the mid-1850s. It is an Italianate mansion. The Cole family only lived in this house for a short time. John Cole and his wife, Eliza, had a falling out, and the two went to live in separate homes. This house passed through a series of owners and was eventually separated into apartments. Currently the home is being restored to a single-family dwelling once again. Original features of this house once included a ballroom on the upper story, complete with cloakroom and raised platform for the orchestra. (Author's Collection.)

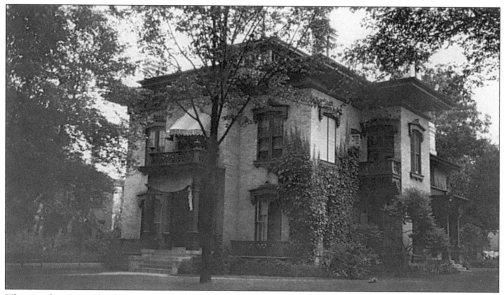

This is the Steimke home located at 422 Spring Street, in a photo taken in 1931. It was yet another of the Italianate-style homes in Watertown. This particular building style proved to be very popular in the 1850s. This house later became an apartment building and was ultimately demolished to make way for the present post office in the early 1960s. (Author's Collection.)

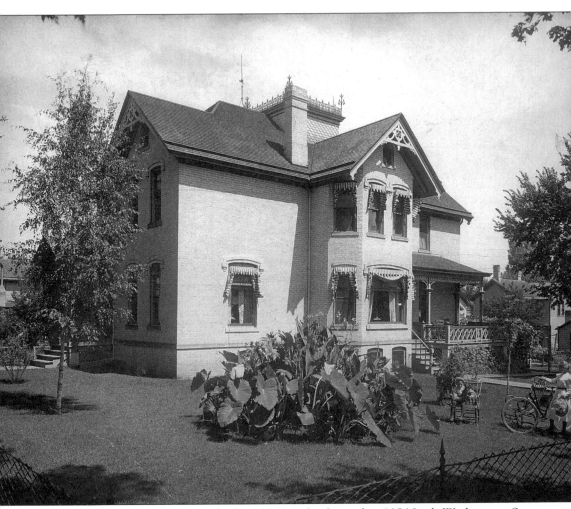

The William Hartig home was built in 1895 and is located at 305 North Washington Street. William Hartig was a prominent brewer. There is a large carriage house in the rear of the dwelling, and today the house has a wrap-around porch. It too has been an apartment house for many years, but plans call for its eventual restoration to a single family home once again. (Author's Collection.)

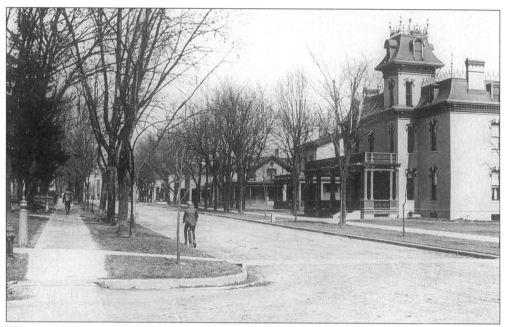

This view depicts some of the houses in the South Washington Street area. This has long been a favored spot for sightseers who wish to glimpse stately old homes in Watertown. The house on the right is the Mulberger Home, owned by a family of mayors and lawyers. Most of the families that lived on this street had ties to the mills which were located a block away. The street has changed very little since this photo was taken in about 1910. (Lindemann Collection.)

This is the Marshall Woodard home on North Washington Street, on January 24, 1927. The Woodards were prominent business people, Marshall Woodard having made his fortune with the Woodard and Stone Cracker Company. His children became lawyers and judges. (Hildebrandt Collection.)

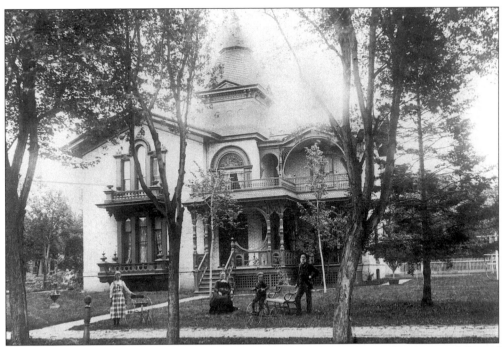

Many homes have suffered at the hands of indifferent owners. This is the George Schempf home, located on South Second and Dodge Streets, as pictured in an image taken about 1895. Notice the beautiful ornamentation and distinctive paladin windows. None of this finery exists on the house as it stands today. (Watertown Historical Society Collection.)

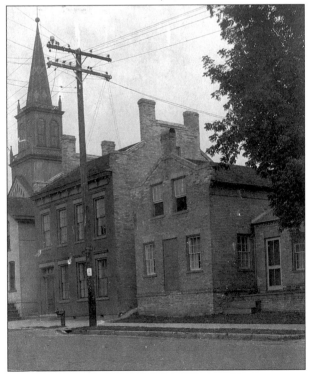

This photo shows the famous German houses of North Fourth Street in 1928. Actually, these houses were built in a Federalist style in the 1850s, and have no traditional German style of construction whatsoever. Notwithstanding, they were associated with German residents, and these homes were often painted and photographed. Note St. Luke's Church building to the left. These buildings were demolished to extend Madison Street and to create a parking lot in the early 1960s. (Author's Collection.)

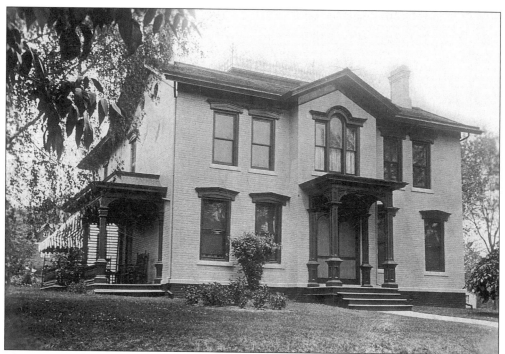

The Daniel Kusel home stands on the corner of North Church and Cady Streets. Originally built in 1849 as a home for Robert Howell, it was enlarged in the 1850s when it was owned by prominent brewer Joseph Bursinger. In the 1870s, it was purchased by Daniel Kusel, who was a pioneer hardware merchant. The bricks on the house are stained pink, and today it serves as an apartment building. (Author's Collection.)

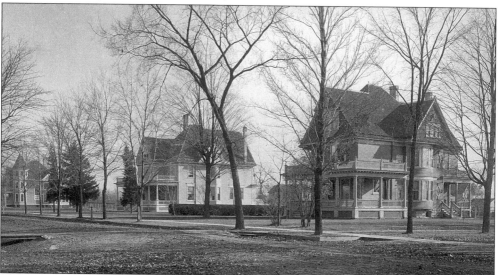

This is Clyman Street around the turn of the nineteenth century. The quiet charm of this street has changed little with the passing years. Most of the homes pictured here are still located on the street. They were the homes of the well-to-do business people who wished to live in what was then considered the quieter, more suburban section of Watertown. (Watertown Historical Society Collection.)

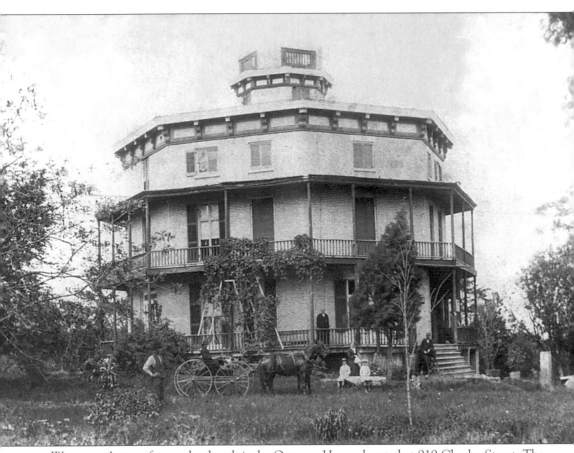

Watertown's most famous landmark is the Octagon House, located at 919 Charles Street. The home was built in 1854 by pioneer lawyer and mill owner John Richards. It has 57 rooms—including the halls and closets—and rudimentary forms of running water, central heating, and air conditioning. Today it is maintained as a museum and is the headquarters for the Watertown Historical Society. (Watertown Historical Society Collection.)

Five

MAIN STREET

The hub of the wheel of commerce was Watertown's Main Street. It served as a gathering place for business people and consumers, and during its heyday, it teemed with shoppers. Sadly, Main Street in Watertown has declined in popularity in the last 20 years or so, but there are signs that business is picking up again.

Retail and commercial businesses were slow to arrive on Main Street. As planned by city designers, the main street was intended to be Western Avenue, and a two-lane street was laid out and constructed accordingly. However, speculators swarmed in and forced a sudden increase in prices for land fronting the street. Small businessmen couldn't afford the prices, and they were forced to relocate further north, along what is today Main Street, and the business district took off.

To quote from a historical report written in 1987 by Joan Rausch, "Most of Watertown's earliest stores were fleeting ones; many were established as the first enterprises of men and women who subsequently became successful in other areas. Some stores were sidelines for professionals who found little professional work available in a pioneer community. Most of these pioneer stores were located in frame buildings that were gradually replaced during the 1850s, 1860s, and 1870s. Main Street, both on the east and west sides of the river, developed as the main commercial district in Watertown...." (City of Watertown, Wisconsin, Architectural and Historical Intensive Survey Report 1986–1987, by Joan Rausch and Carol Lohry Cartwright, LaCrosse: Architectural Researches, Inc. August 1987)

The first commercial structure on Main Street was the Exchange Hotel, built in 1840, followed by the Cole Brothers general store in 1841. By 1845 there were about 11 stores dotting the street, and by 1856 that number had grown to 96 commercial or retail stores. The numbers kept growing as new settlers continued to arrive throughout the nineteenth century. Though Watertown would develop a successful local industrial base during the late 1800s and early 1900s, it was the commercial success of its downtown that helped to make and maintain the city's importance as a center of economic activity in southeastern Wisconsin.

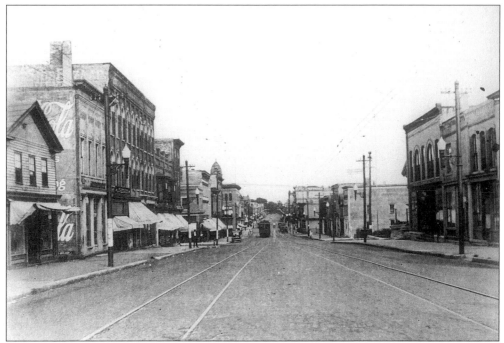

Main Street, Watertown, Wisconsin, is depicted here in a photo taken by William Streblow on August 22, 1920. Mr. Streblow was an amateur photographer with a keen eye for detail. Of this photo, which shows the intersection of Main and Washington Streets looking east, he wrote: "A fine view down Main Street...looking east. The high building to the left is the Belvidere Hotel. The high building to the right is the Central Trading Co. The street car is just on the bridge. Watertown is a beautiful city...." (Hildebrandt Collection.)

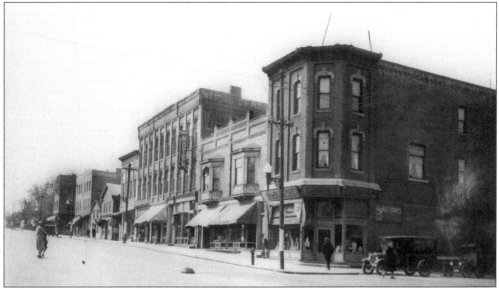

This is a photo of Main Street at the intersection of Water Street looking west in about 1927. The building in the center was the former Baumann Candy Kitchen, and it is currently a women's fitness center. (Hildebrandt Collection.)

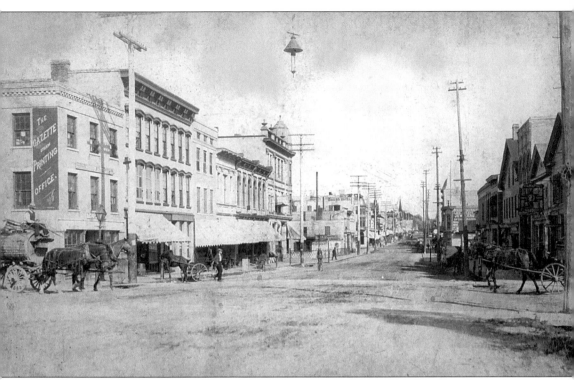

The intersection of Main and Water Streets looking east is shown here in a photo dated about 1895. The street was not bricked until 1899 and could be difficult to travel on in rainy weather. (Author's Collection.)

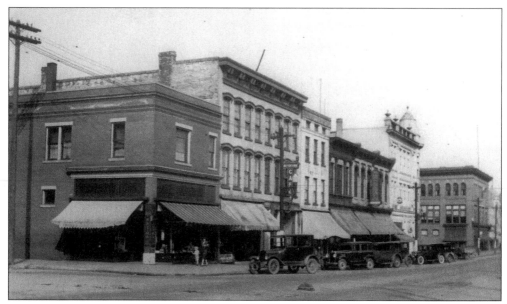

This is the same view as shown on page 73, taken in 1929. Note that the buildings have not changed dramatically since the earlier photo. Watertown has one of the largest historical districts in southeastern Wisconsin, which is comprised chiefly of its Main Street area. Most of the buildings on Main Street date to the mid-nineteenth century. (Hildebrandt Collection.)

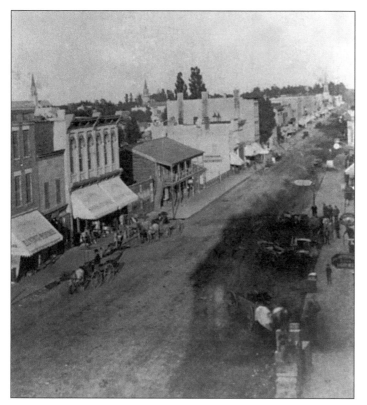

This is Main Street in 1870 showing the bridge and the Werner Building or "German Bazaar," which dated to the early 1850s. This building, with the canopy in the center of the photo, was built on pilings off the north side of the Main Street bridge. It was swept away by ice floes after the great snow storm in March of 1881. (Watertown Historical Society Collection.)

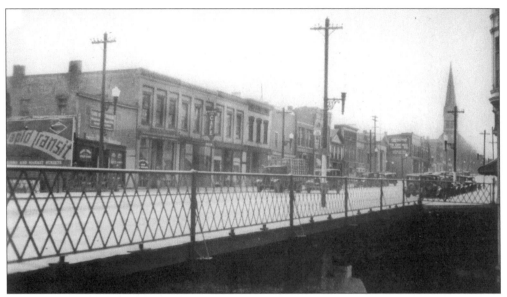

This is a view of Main Street looking west from the bridge in about 1929. Apart from some remodeling, the buildings pictured here still stand. (Hildebrandt Collection.)

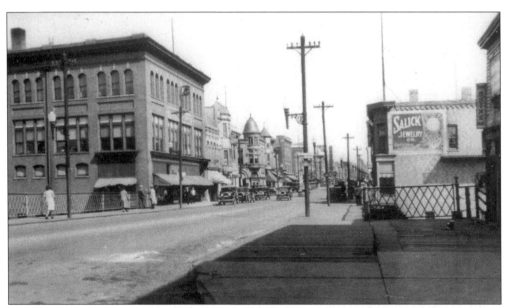

This photo depicts Main Street from the bridge looking east in 1929, showing the Masonic Temple—now Fischer's Department Store—on the left and the former Salick Jewelry Store building on the right. The Salick building, listed as Number One Main Street, was demolished in the late 1980s to create a courtyard for the boardwalk along the river. (Hildebrandt Collection.)

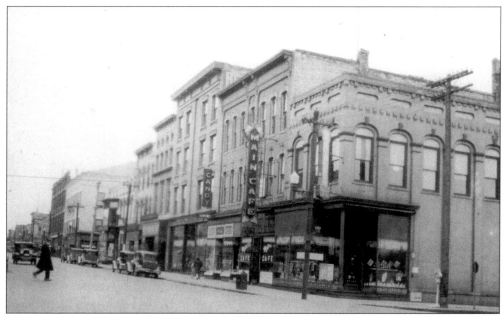

This image shows Main and First Streets looking to the east. The building on the right is the former post office block, constructed about 1871. Besides the post office, it has also housed city hall, the telephone company, and the first home of the Watertown Daily Times. A real estate company is currently located in this building. This picture was taken in 1929. (Hildebrandt Collection.)

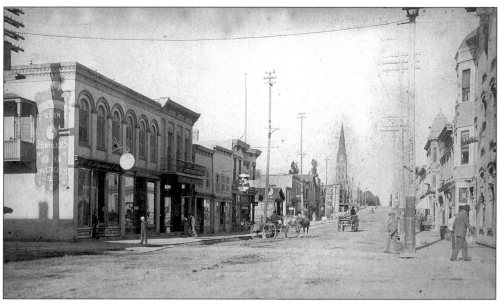

This image shows the intersection of Main and First Streets looking to the west in 1895. (Author's Collection.)

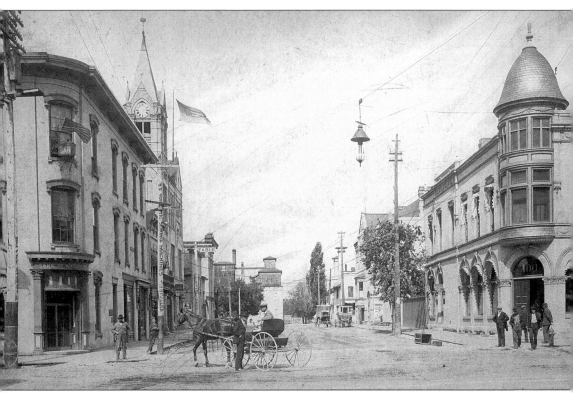

This photo shows the intersection of Main and First Streets in 1895. Note the Welsbach Street light and the Fuermann Brewery buildings in the distance. The large building on the right is the Merchants Bank, built in 1892, and on the left is the Bank of Watertown. The steeple belongs to the old City Hall, built in 1885. (Author's Collection.)

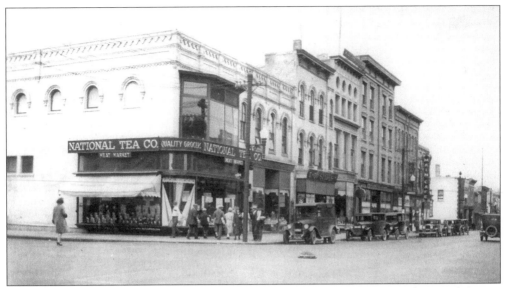

This image, which was taken in 1927, shows the intersection of Main and Second Streets looking west. The store on the left, the National Tea Company, was the site of the first store in Watertown in 1841. (Hildebrandt Collection.)

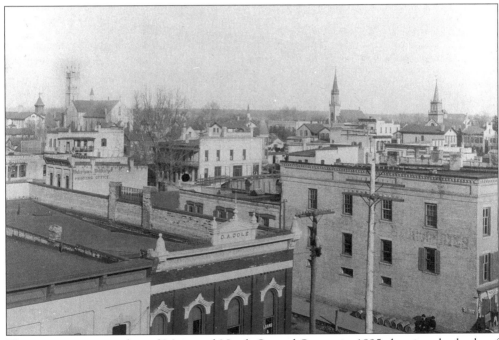

This is an interesting shot of Main and North Second Streets in 1895 showing the backs of buildings in the downtown district. Note St. Henry's Catholic Church in the distance on the left, with the parish school next to it; on the right is St. John's Lutheran Church, and on the far right, St. Luke's Church. The Moravian Church steeple is just visible between St. Henry's and St. John's Churches. (Watertown Historical Society Collection.)

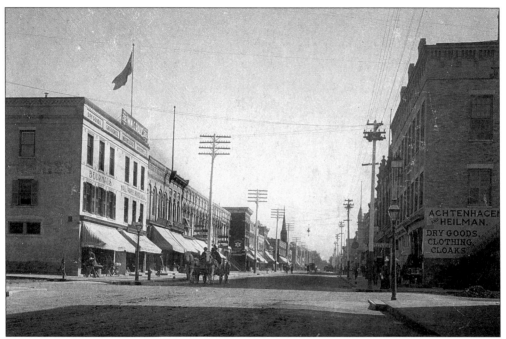

Main and Second Street as pictured in 1895 is depicted here. The Beuerhaus-Gloger Shirtwaist Factory is pictured on the left, and the Cole Block is on the right. Both buildings still stand on Main Street. (Author's Collection.)

The intersection of Main and Third Streets is pictured here about 1910. The building on the right is the Deutsches Dorf saloon, a popular gathering place. This later became the home of the gas and electric company. Today these buildings are all part of a shoe store. (Lindemann Collection.)

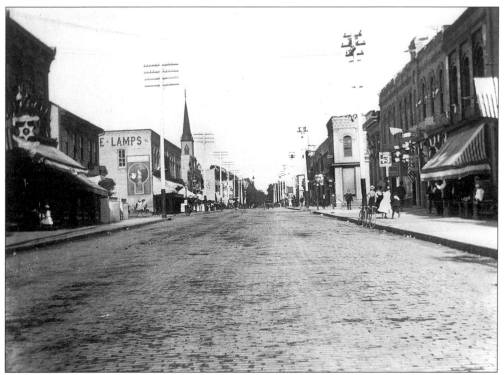

Photographed in June 1900, this dramatic image depicts Main Street looking east from the intersection of Third Street. The absence of people leads one to believe this was either an early morning or Sunday morning photo. (Krueger Collection.)

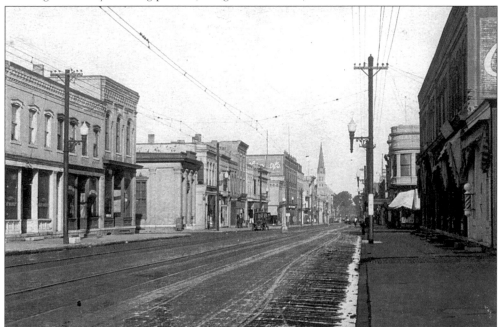

This is another shot of Main Street, from Fifth Street looking westward. Note the trolley tracks and bricked street. This photo dates to about 1920. (Author's Collection.)

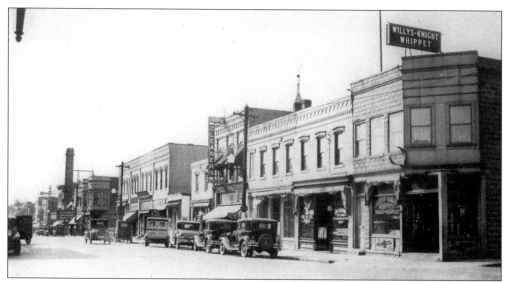

Main Street from the intersection of Fifth Street is pictured here in about 1929. It is interesting to note that the building on the far right, which was a garage, was demolished when Fifth Street was widened in the late 1950s. Next to it is the tavern belonging to Arthur "Turkey" Gehrke, who was known for "hibernating" every winter. (Hildebrandt Collection.)

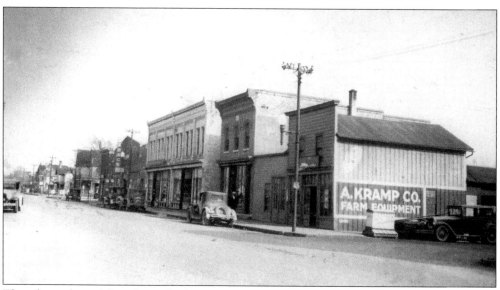

This photo shows Main Street looking east from Fifth Street. The small building on the right has long since been demolished and is currently a parking lot for a funeral home. (Hildebrandt Collection.)

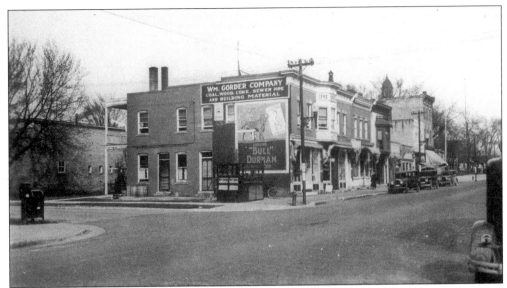

This photo, taken about 1929, shows the intersection of Main and Sixth Streets looking to the east. This complete block of buildings was demolished in the 1960s to make room for a bank. This was formerly the William Gorder Block. In Watertown, the rule of thumb once was "if it isn't a bank, its a parking lot. And if it isn't a parking lot, its a bank." (Hildebrandt Collection.)

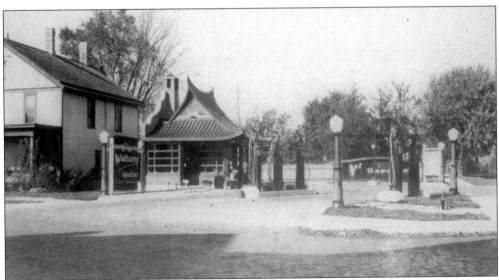

This photo, taken about 1921, shows the Wadham Gas Station, which was located on the corner of East Main and North Ninth Streets. This gas station, with its distinctive pagoda-like roof line, has since given way to a more nondescript commercial building. (Hildebrandt Collection.)

Six

PEOPLE

From the earliest days of its settlement, Watertown has always attracted unusual and colorful personages. Timothy Johnson, for example, couldn't sit still for too long. He was forever traveling in search of some Eldorado somewhere and ultimately died in an asylum. Henry Bassinger, on the other hand, never drank a drop of pure water after seeing dead horses in a stream during an encampment in the Civil War.

Charles Gardner was the only person from Watertown to actually leave the city and join the southern army during the Civil War. Ellen McDermott was known as "Crazy Nellie"—she used to shout obscenities at the potato bugs infesting her plants. Maggie O'Connell was a petty thief and vagrant who made life miserable for her jailers. Last but not least, Mary Grueztmacher ran a notorious brothel in the southern part of the city in the 1880s. Their antics certainly made for hot newspaper copy in the "good old days."

But lest the reader think that only eccentrics populated the city, it would be well to remember that Watertown gave birth to the inventor of the automatic cashier, an ambassador to Russia, the editor of the *London Daily Express*, and many lawyers, teachers, artists, and inventors. As the introduction to this work stated, history is not made by demi-gods. It is made by common, fallible people who make mistakes, and those are some of their most endearing qualities.

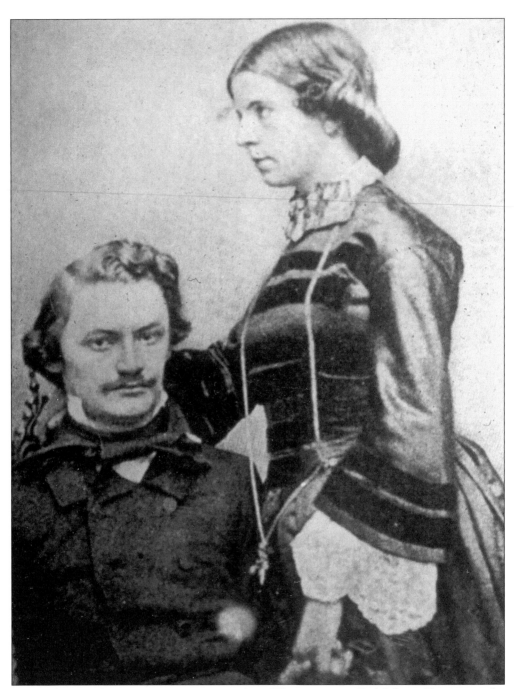

One of the most famous personages to come from Watertown was Carl Schurz. He came to the city in 1855 and began his political career by serving as an alderman for the old Fifth Ward. Schurz left the city in 1857 and first went to Milwaukee, then to St. Louis, where he ran a newspaper. He served as ambassador to Spain, was a general in the Union Army, and later served as secretary of the interior during the administration of President Rutherford B. Hayes. He is pictured here with his wife, Margarethe, who founded the first Kindergarten in America in Watertown in 1856. (Watertown Historical Society Collection.)

Theodore Prentiss became the first mayor of Watertown when it was granted city status in 1853. He was a native of Vermont and came to the city in 1845 to practice law. He was also involved in real estate and banking. (Watertown Historical Society Collection.)

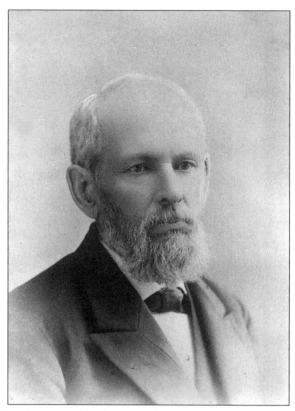

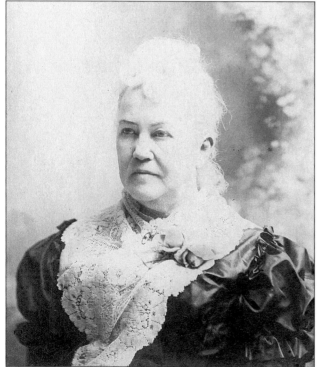

Eliza Fiske Cole, the wife of John W. Cole, is depicted in this portrait from 1895. She was a formidable woman who did not enjoy the deprivations and hardships of pioneer life. Her greatest joy was to dress in full riding attire and ride her white steed up and down the streets of Watertown. (Watertown Historical Society Collection.)

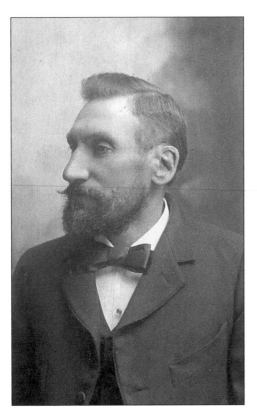

This photo depicts Carl Manz, who was a partner in the brewery of William Hartig. A nephew of Mrs. Joseph Schlitz, it was he—according to legend—who arranged for the funding necessary to break into the brewing business in Watertown in 1884. He was also distantly related to William Hartig, who bought his interest in the brewery in 1896. A civic-minded man, Carl Manz was very much involved in beautification projects. He died in 1903. (Author's Collection.)

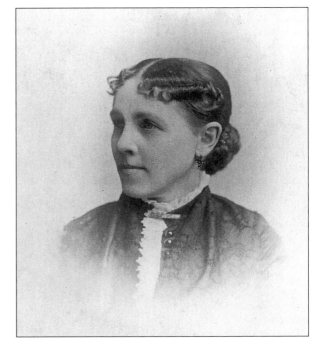

Libby Atwater, pictured here, was a niece of John Richards. He brought her to Watertown in the 1840s to teach in the school he built on the east side of Watertown. Some time later she met Anson Caniff, one of the laborers in John Richards's mill, and they fell in love and were married. She is credited with being one of the first female teachers in the city. (Watertown Historical Society Collection.)

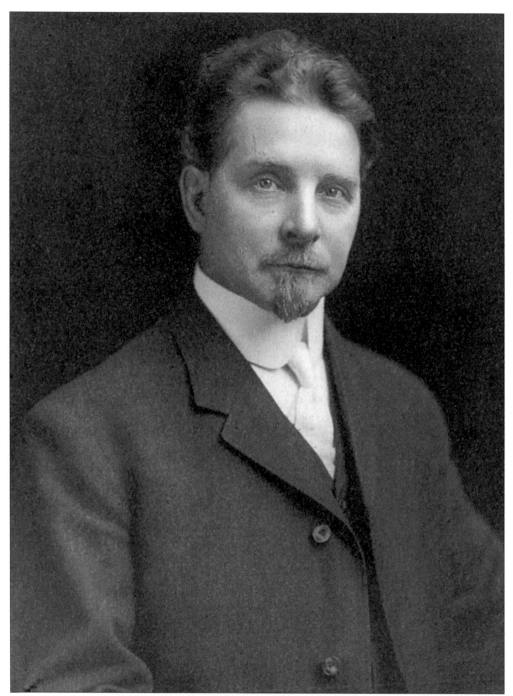

During the late nineteenth century, Edward J. Brandt, pictured here, was a teller at the Bank of Watertown. One of his duties was the preparation of cash payrolls for local railroad employees. It was time-consuming, and he decided to invent a better way to count coins. His invention led to the Brandt Automatic Cashier, which is still in use all over the world. Brandt was known as the "Watertown Edison," and he held 79 U.S. Patents in his lifetime. (Author's Collection.)

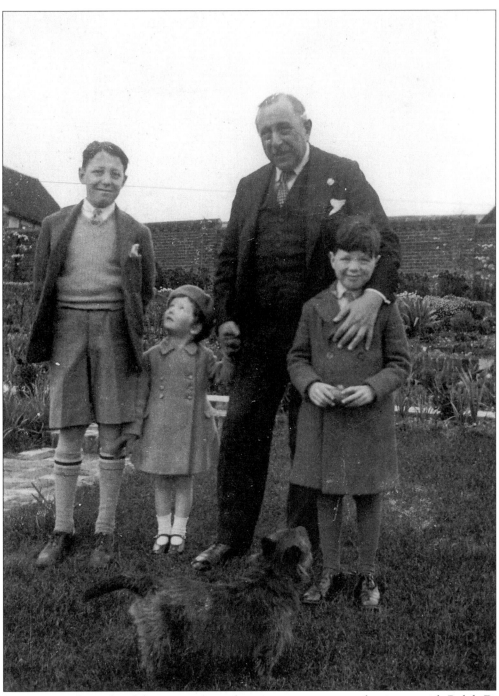

Some persons have the ability to rise from obscurity to greatness, and so it was with Ralph D. Blumenfeld, pictured here with his grandchildren on his estate "Muscombes" in England in 1935. The son of the editor of the *Watertown Weltburger*, the German language newspaper, he rose through the ranks to become the editor of the *London Daily Express* and was later an author of several very entertaining books, among them *Home Town*, which was a book of recollections of his childhood in Watertown. (Author's Collection.)

Joseph E. Davies and his mother, Rachel, are pictured here in an image taken in 1898. Rachel Davies, also known as Rahel O'Fon, was the first ordained female minister in Wisconsin. Her son went on to become a successful lawyer and later served as ambassador to Russia during the administration of Franklin Delano Roosevelt. (Watertown Historical Society Collection.)

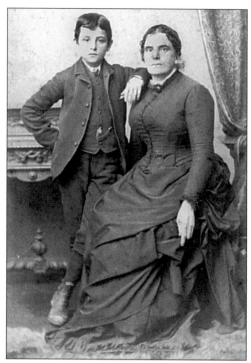

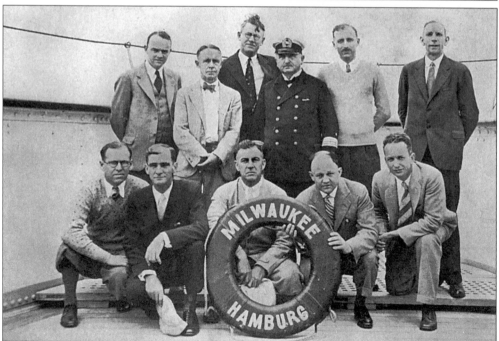

This photo depicts the men who were sent to Europe by the Carnegie Endowment for Peace in 1931. In the lower row, fourth from the left is Edwin Witte, a former Watertown resident and the man who drafted the Social Security Act in 1935. He was a professor of economics at the University of Wisconsin, and the university named a dormitory after him following his death. (Author's Collection.)

Jacob Bell Van Alstine, pictured here in an image taken about 1880, was the irascible proprietor of the Exchange Hotel from 1848 until his death in the late 1880s. He was a hard man to deal with, but he was fair. Many stories were told of his dealings with guests and their trying times with him. (Author's Collection.)

Mary Van Alstine Wright-Bartow is depicted here in a portrait from 1880. She was the only child of Jacob Van Alstine. Mary was an artist at a time when women artists were few and far between. She made a fair living from her paintings, which were mostly landscapes and still-lifes. (Author's Collection.)

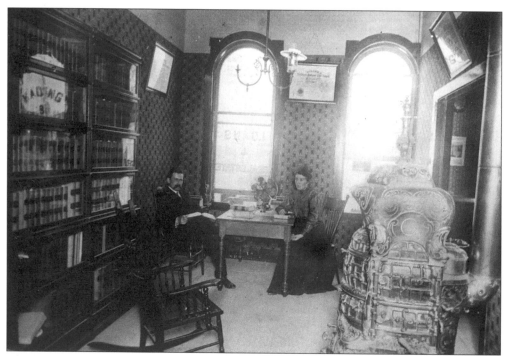

Charles and Elizabeth Kading are pictured here in their law office in Watertown about 1905. The Kadings were a rare example of a family of lawyers. Mr. and Mrs. Kading were both lawyers, and their son, named Charles as well, also became a lawyer and later a judge. (Watertown Historical Society Collection.)

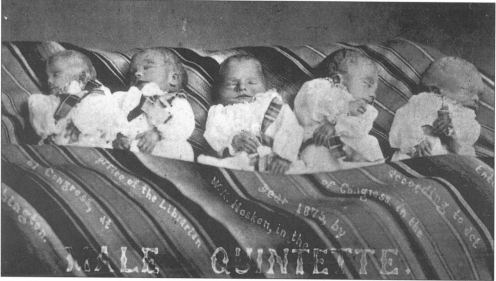

The Kanouse quintuplets are depicted here in a picture taken shortly after their death on February 13, 1875. They died about two hours after they were born. The children, all boys, were the first recorded case of quintuplet birth in the United States. They were buried in secret for fear of being put on exhibition, only later to be placed on exhibition in their grandfather's office. (Author's Collection.)

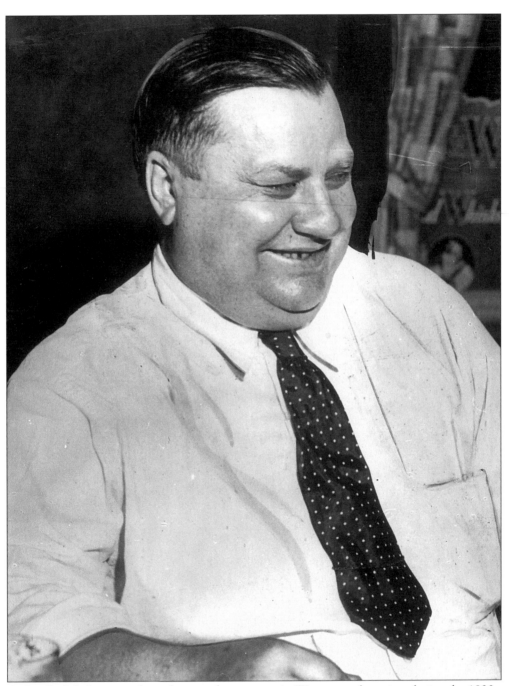

Arthur E. Gehrke was perhaps the most famous man in Watertown for a time during the 1930s. He was famous around the globe, being interviewed by the BBC and featured on *Ripley's Believe It Or Not* radio program. What was Gehrke's claim to fame? He felt that cold, wintry weather brought on chest and leg pains, and so he would take to his bed and rest for six months out of the year annually. He was called "Turkey" Gehrke because a little boy could not pronounce his name properly, and it came out sounding like "turkey." He operated a bar on Main Street called "Turkey's Roost." (Watertown Historical Society Collection.)

92

Emil Meyer was a philosopher and a barkeeper for Henry Daub in his "Excelsior Beer Hall." He was considered one of the friendliest men in Watertown and was thought highly of by many. The caption on this photograph reads (in German), "Boys! Don't Argue with me!" (Watertown Historical Society Collection.)

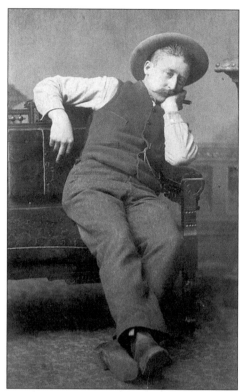

John B. May was one of the most popular photographers in Watertown from the 1870s through the 1890s. He captured the likeness of virtually every individual in the city. In addition to photography, he is also credited with bringing the telephone to Watertown and starting the local telephone company here in 1877. He is also credited with inventing an electric burglar alarm. (Watertown Historical Society Collection.)

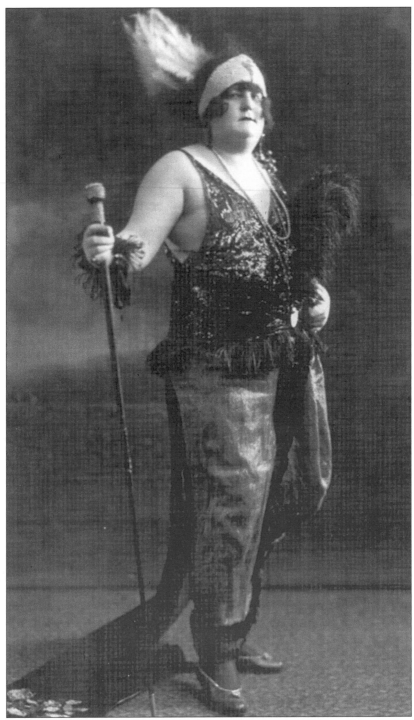

In the old days, men were men and sometimes...they were women! This is "Francine", the alter-ego of Frank Cook, Watertown's famous female impersonator. He was a vaudeville performer around the time of the First World War. After his retirement he became a bartender at the Carlton House Hotel in Watertown. (Steve Hady Collection.)

Seven

THIS AND THAT

This chapter contains images that do not quite fit under any other category. They are scenes of parades, sporting events, disasters, and views of buildings and places in Watertown. There is a lot of beauty in commonplace, everyday things. Few people stop to contemplate that fact. This chapter will hopefully bring these simple, yet interesting, things to light. So, let us begin by looking forward.

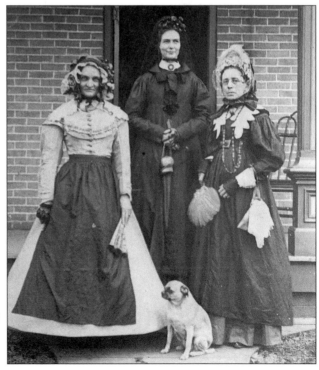

A group of Watertown women—Miss Kidder, Miss Hall, and Mrs. Skinner—are pictured on their way to an "Old Maid Party" in 1890. These gowns were examples of the height of fashion in 1850. (Watertown Historical Society Collection.)

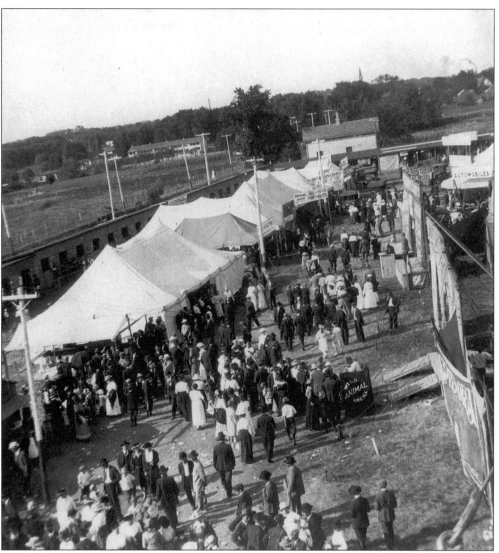

This is a view of the old Inter-County Fairgrounds, located along Utah Street in the southern part of the city. A fair was held here every year from the turn of the century until 1927, when the buildings were sold off and the area itself sold for real estate purposes. (Watertown Historical Society Collection.)

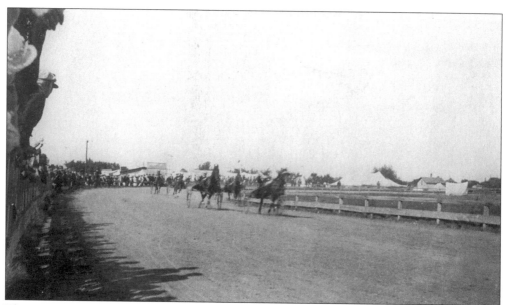

This is a scene at the races at the fairgrounds, c. 1915. The fairgrounds contained a fine racing track as well as several exhibition halls. (Lindemann Collection)

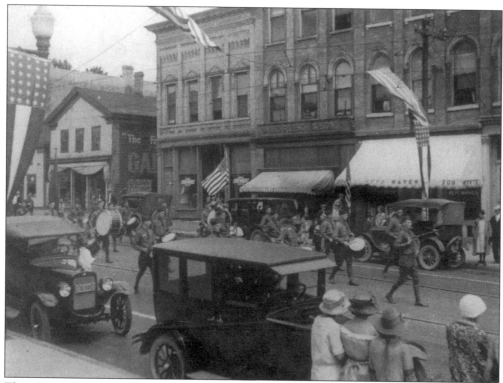

The State Fireman's Tournament Parade was held in Watertown on June 18, 1925. (Hildebrandt Collection.)

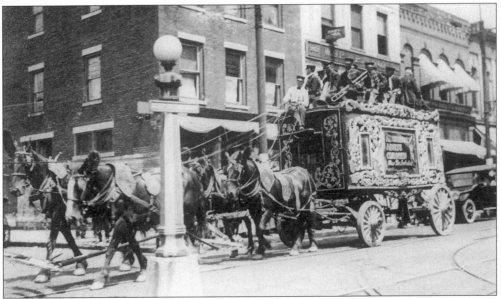

This photo depicts a circus parade in Watertown, July 19, 1920. This was the Walter L. Main Circus coming down Main Street, heading towards the circus grounds in the old Fifth Ward. This view shows the parade crossing through the intersection at Main and Second Streets. (Hildebrandt Collection.)

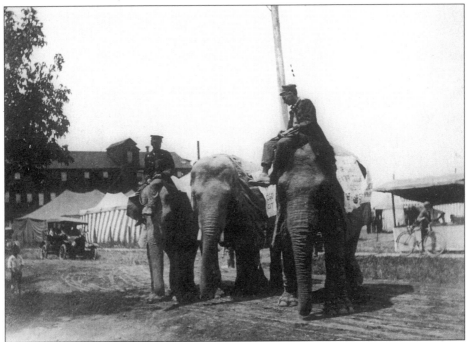

This is another shot of the Main Circus and their elephants at the old circus lot in the Fifth Ward, which is today the site of Lincoln Park. William Streblow, who took this picture wrote: "The three elephants of Walter L. Main's show. That was all they had in the elephant line. Then they had one lion, a few ponies, and some foxes and parrots. Some menagerie!" (Hildebrandt Collection.)

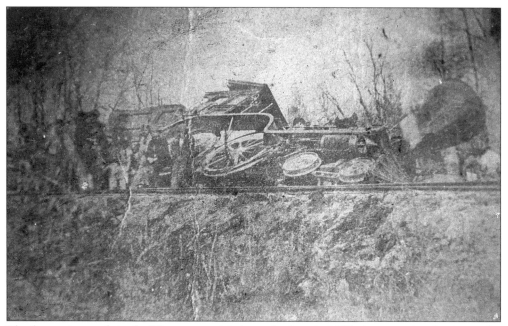

The first train wreck in the Watertown vicinity took place in 1859. A promotional train on the Northwestern Line which carried six hundred passengers from Fond du Lac to Chicago was derailed near Johnson Creek when the engine hit a bull. Fourteen people lost their lives, and 35 were seriously injured in the catastrophe. This image depicts the wreckage. (Author's Collection.)

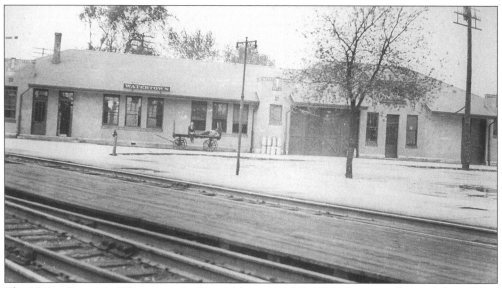

The Union Depot in Watertown is pictured here in 1929. This depot was located along West Street and was torn down in 1995 after standing unused since the last passenger train came through Watertown in 1971. (Hildebrandt Collection.)

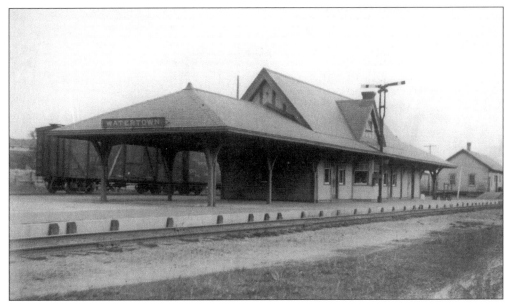

This is the Chicago and Northwestern Depot, which stands on West Main Street in Watertown. This photo was taken June 5, 1926. This is the only one of three depots still remaining in the city. Today this depot is used as a florist's shop. (Hildebrandt Collection.)

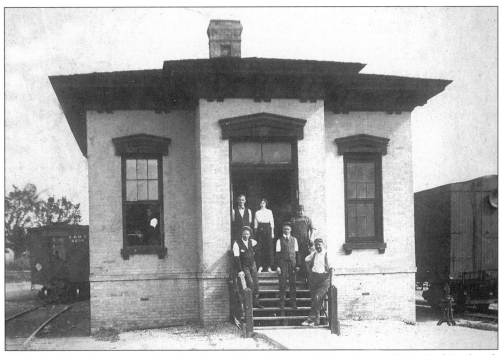

This is a 1900 photo of the freight office of the Chicago, Milwaukee, and St. Paul Railroad, located at 1017 South Fifth Street. This building still stands. (Author's Collection.)

Watertown had a trolley line that ran through the city from 1908 to 1940. This scene, photographed about 1916, shows one of the trolleys at the intersection of Main and First Streets. Note that the Bank of Watertown building on the left is absent. It was demolished in 1916 and rebuilt that same year. (Stuebe Collection.)

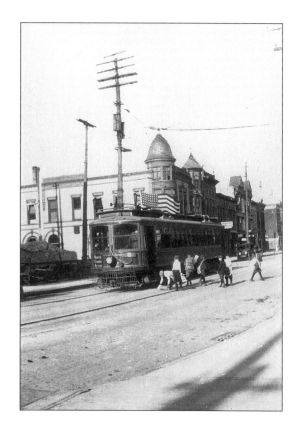

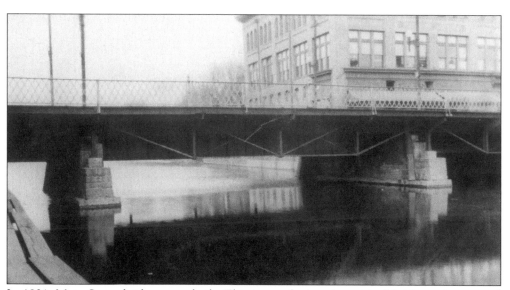

In 1931, Main Street bridge was rebuilt. This image depicts the original bridge as it appeared before it was dismantled and reconstructed. (Hildebrandt Collection.)

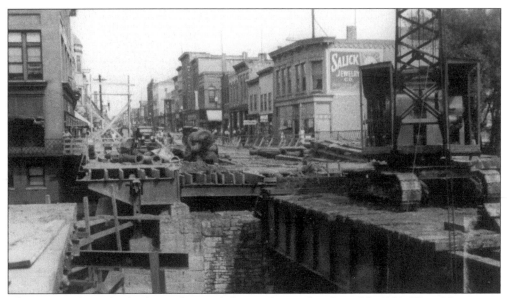

This is Main Street bridge being dismantled, in a photo taken June 27, 1931. The old pier, one of two under the old bridge, is visible in this picture taken by William Streblow. (Hildebrandt Collection.)

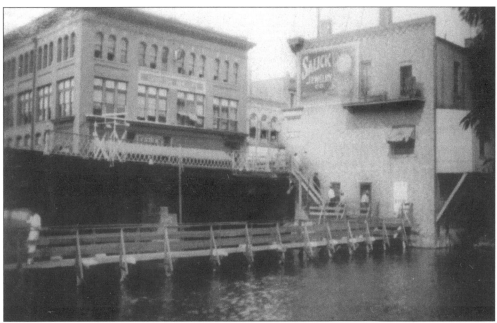

While Main Street bridge was being rebuilt, there was a footbridge that was used by pedestrian travelers. This is a view of that bridge taken June 27, 1931. (Hildebrandt Collection.)

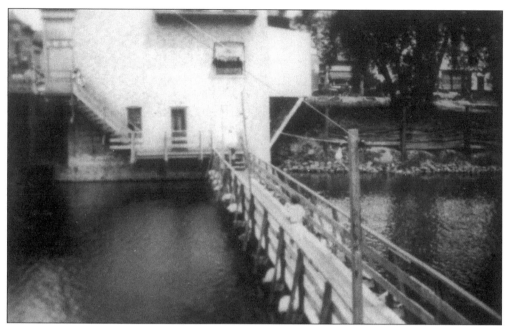

This is another view of the footbridge constructed alongside Main Street bridge. (Hildebrandt Collection.)

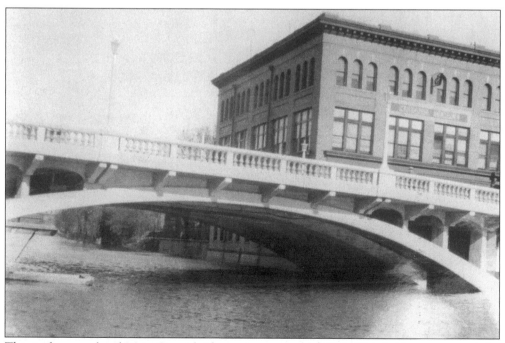

This is the completed Main Street bridge as it appeared in 1931. This bridge was named the John W. Cole Memorial Bridge, since money from his will contributed to its construction. (Hildebrandt Collection.)

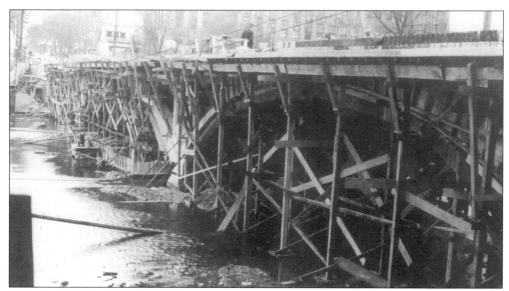

Milwaukee Street bridge was rebuilt in 1930, and this image depicts its construction. (Hildebrandt Collection.)

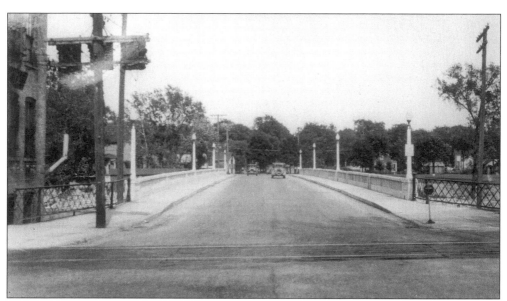

The completed Milwaukee Street bridge, c. 1930 is pictured here. (Hildebrandt Collection.)

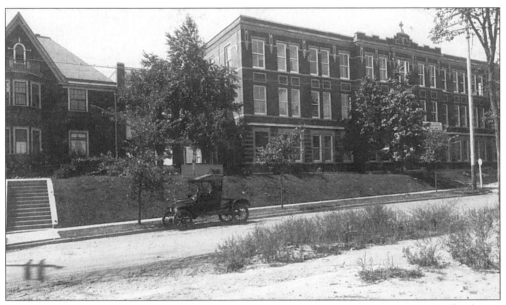

This image shows St. Mary's Hospital in 1920. The hospital originated in the Schiffler home on East Main Street, which can be seen on the left side of the hospital building in 1907. In 1919, the large hospital building was erected and is visible on the right side of the photo. It later became the Watertown Memorial Hospital and moved to modern, more spacious quarters in 1971. (Author's Collection.)

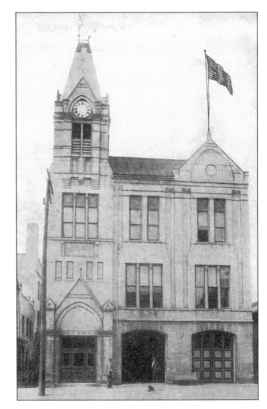

This photo depicts the Watertown City Hall, located on North First Street. This imposing building was erected in 1885 and housed not only the city offices, but also the jail and fire department. It was torn down in 1965 to create a charming parking lot. (Author's Collection.)

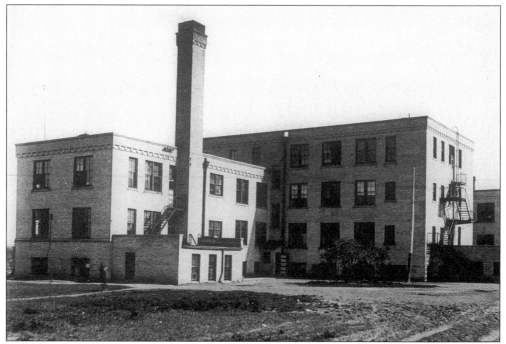

Bethesda Lutheran Home is pictured in this image taken on May 16, 1921. It is a nationally recognized care facility for persons with developmental disabilities. The home was founded by the Missouri and Wisconsin Lutheran Synods in Watertown in 1904, and after a time moved to its present location in the southwestern part of the city. (Hildebrandt Collection.)

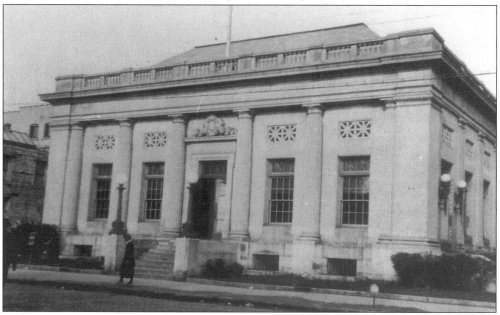

Watertown's post office was located on North Second Street for many years. This imposing structure was built in 1912 and was used until the mid-1960s, when a new office was erected. This later became a clubhouse for the Moose Lodge, and it was finally torn down in about 1972 to make way for a very lovely parking lot. (Watertown Historical Society Collection.)

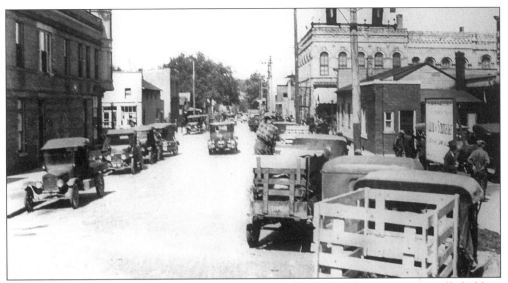

Fair Day in Watertown has been a tradition since October 1860. This event, originally held on the second Tuesday of each month, was created to allow farmers to buy and sell animals and produce. This photo, taken June 14, 1927, shows Fair Day in progress on East Madison Street. (Hildebrandt Collection.)

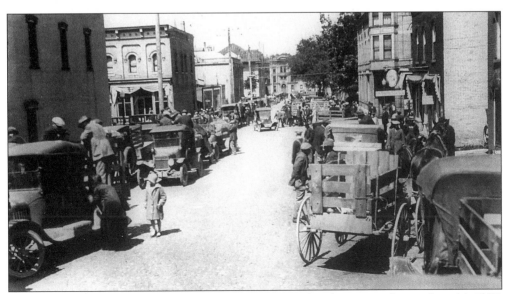

This is a photo of Fair Day taken on East Market Street. This photo was taken on June 14, 1927. (Hildebrandt Collection.)

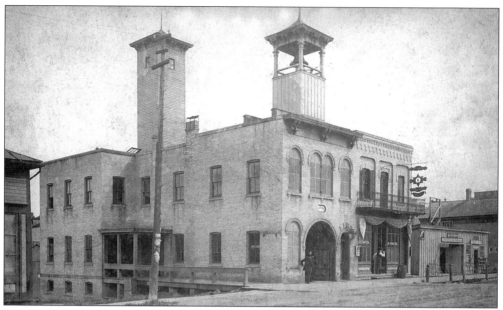

The Phoenix Fire Department is depicted here in a photo taken about 1895. This fire station, located on North Water Street, was built in 1876 for a second city fire department. The Phoenix Fire Department merged with the main fire department shortly after the turn of the century. This building currently houses a bowling alley and bar and grill. (Author's Collection.)

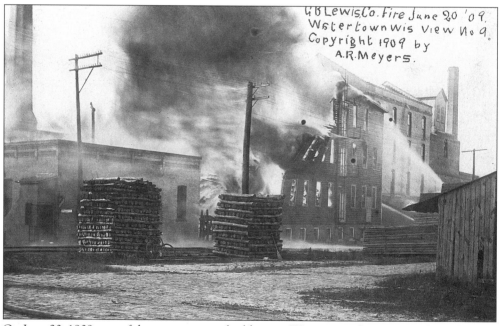

GB Lewis Co. Fire June 20 '09.
Watertown Wis View No 9.
Copyright 1909 by
A.R. Meyers.

On June 20, 1909, one of the most spectacular blazes in Watertown's history wiped out the G.B. Lewis Company. This view, one of a series of 10 postcards taken by A.R. Meyers, depicts the main building engulfed in flames. (Watertown Historical Society Collection.)

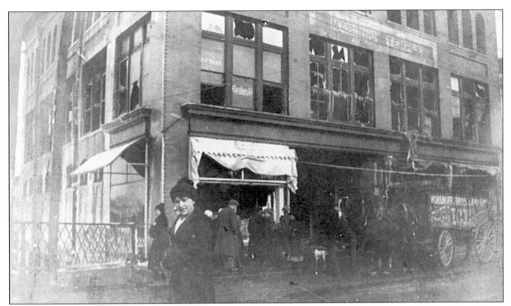

Another disastrous fire took place on February 19, 1916, when the Masonic Temple building on Main Street caught fire. The building was gutted, temporarily displacing Fischer's Department store and the office of the *Watertown Daily Times*. (Author's Collection.)

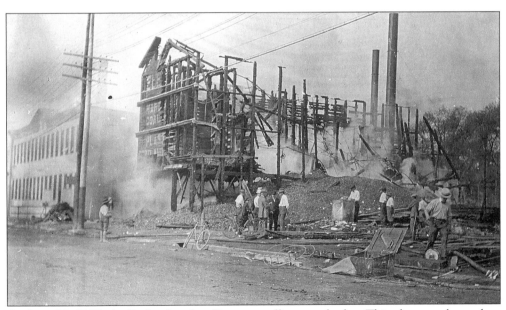

On June 29, 1915, the Barker Lumber Company offices caught fire. This plant was located on South First Street. (Author's Collection.)

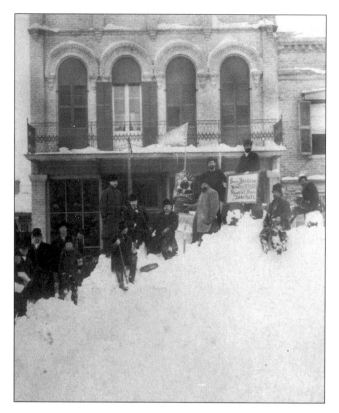

It was not just man-made disasters that caused problems. Often the weather would play havoc with the daily routine. This shows the great snowstorm of March 1881, which crippled the city for nearly a week. (Watertown Historical Society Collection.)

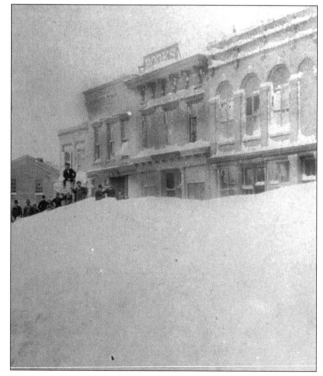

This is another view of Main Street during the great snowstorm of 1881. The Exchange Hotel is visible on the far left of this photo. (Watertown Historical Society Collection.)

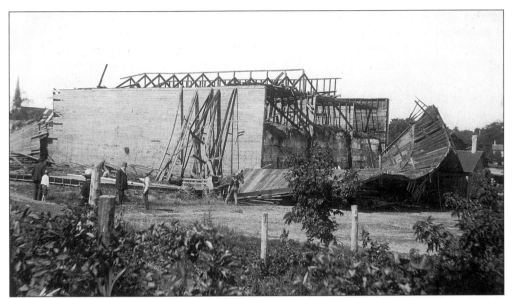

Another weather-related disaster was the cyclone that struck Watertown on June 23, 1914. It caused major damage in the north-western parts of town. This image depicts the destruction of William Hartig's ice house. (Author's Collection.)

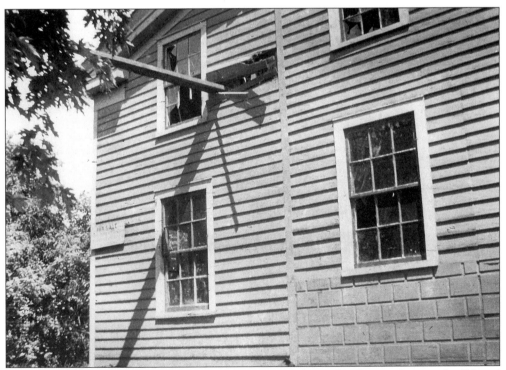

This is another view of the 1914 cyclone wreckage. It shows the damage done to the Edward Lietzke home, located on the corner of North Second and Lynn Streets. The piece of timber pictured here was blown into the side of the house by the force of the cyclone, injuring Mrs. Lietzke who was closing a window at the time. (Stuebe Collection.)

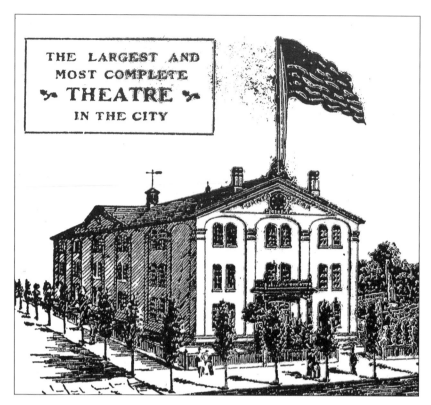

This sketch shows the Turner Opera House, which was one of the largest theaters in the city. The Turner Society was organized in 1860, and they erected a hall in the 1870s. (Watertown Historical Society Collection.)

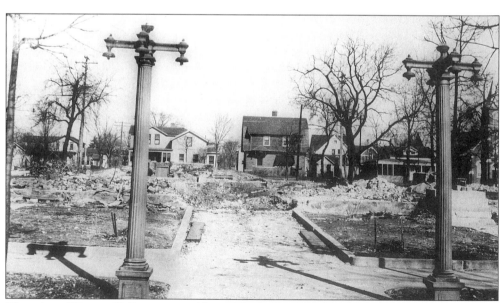

The ruins of Turner Hall are pictured here. The hall caught fire in March 1928, and it burned to the ground. A new building was erected on the ruins and opened in 1929. (Hildebrandt Collection.)

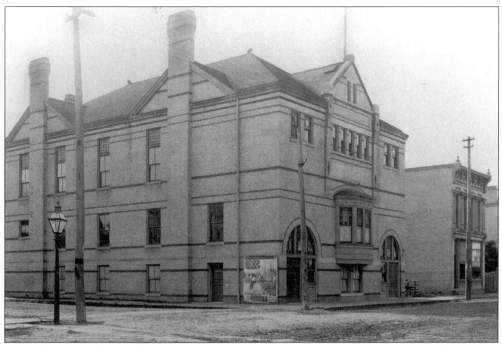

The other major theater in Watertown was the Concordia Opera House, built by the Concordia Opera Society in 1888. This hall, which is currently the headquarters of the Elks Lodge, is located on North First Street. (Watertown Historical Society Collection.)

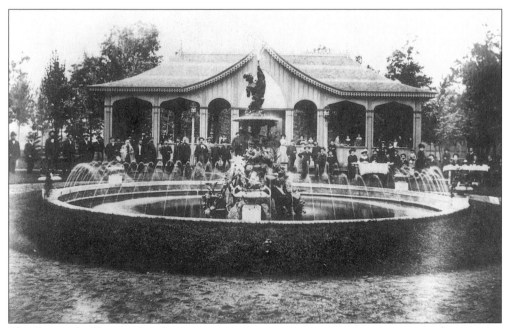

The Concordia Society, besides staging operas, competing in singing contests, and promoting theatrical and cultural events, also owned an island on the east side of the city known as Concordia Island. This island, minus the large pavilion, is known today as Tivoli Island. (Watertown Historical Society Collection.)

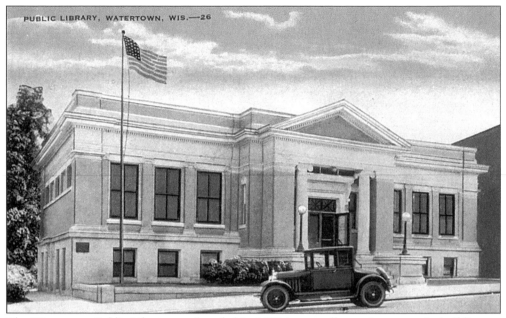

The Watertown Public Library was founded in 1903 in a small upstairs room of a building on Main Street. In 1907, through a generous gift from the Carnegie Foundation, this impressive library building was erected. (Author's Collection.)

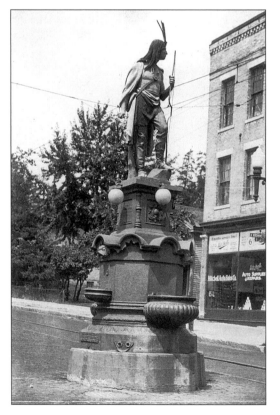

This imposing monument was originally located in the intersection of Main and Washington Streets. It was originally a drinking fountain. The monument was a gift to the city from the George B. Lewis family in 1896, and stood there until 1926 when it was struck by a car and destroyed. A duplicate of the statue was ordered by the city and placed first in Union Park and later moved to the grounds of the Octagon House museum, where it remains today. (Author's Collection.)

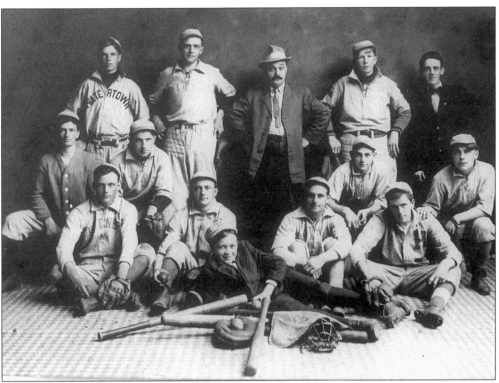

Baseball has been a popular sport in Watertown since the late 1860s. This is just one of many teams that played in the leagues of long ago. This is the Bittner's baseball team about 1910. Bill Jannke, the author's grandfather, is standing second from left. (Lindemann Collection.)

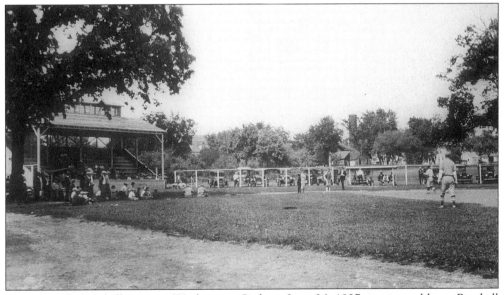

The start of a baseball game at Washington Park on June 26, 1927, is pictured here. Baseball games were, and still are, played at this public park since the turn of the century. (Hildebrandt Collection.)

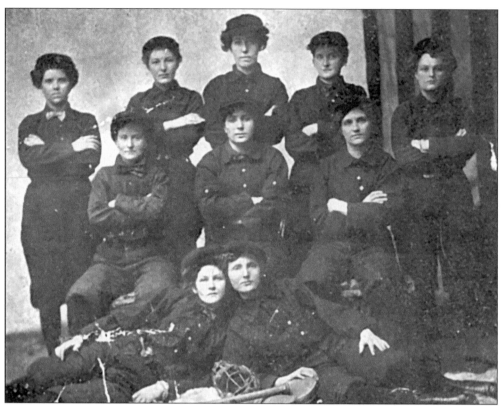

Men were not the only ones who engaged in sports. In 1900, Watertown had a women's baseball team known as the Bloomers. (Watertown Historical Society Collection.)

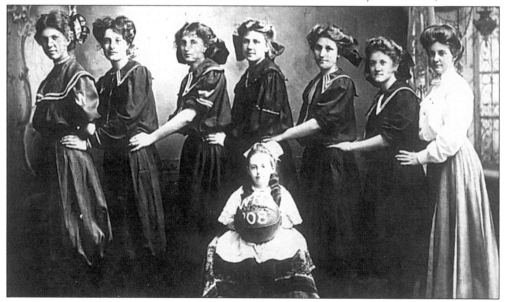

In 1908, Watertown had a women's basketball team, which is pictured here. The note on the back of this image reads, "Don't you think this is a fine bunch? Never will there be another team like the '08!" (Watertown Historical Society Collection.)

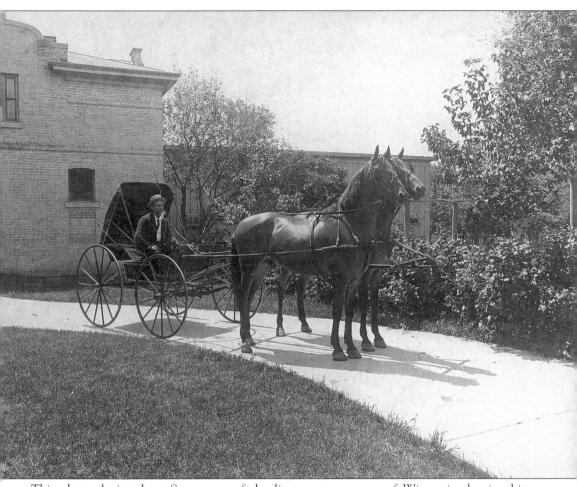

This photo depicts Jesse Stone, son of the lieutenant governor of Wisconsin, leaving his parents' carriage house on South Washington Street. The spanking team he is driving served as his racing team. Horse racing was a popular sport in these days. (Watertown Historical Society Collection.)

Watertown has always been a city of hotels. At one time there were ten hotels, and each was filled to capacity on a weekly basis. This is the Northwestern Hotel, which catered to passengers and crew members of the Northwestern Railroad. It was located on West Main Street and was torn down in the early 1990s. This photo was taken on June 8, 1926. (Hildebrandt Collection.)

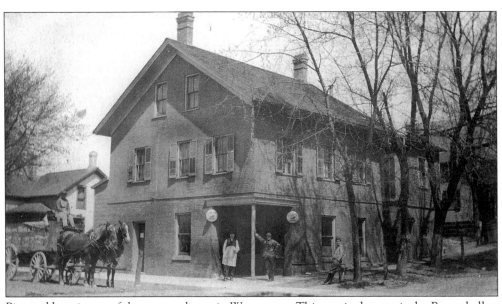

Pictured here is one of the many saloons in Watertown. This particular one is the Bumpskeller, located on North Second Street. Note the ice wagon on the left and the advertising signs for Hartig's beer that flank either side of the door. (Lindemann Collection.)

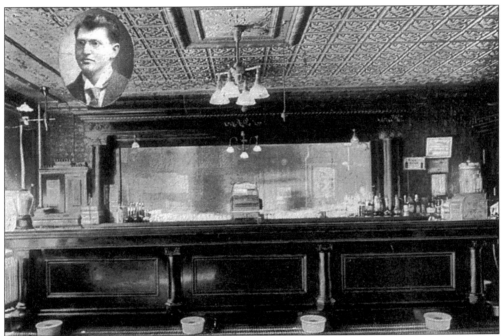

The interior of Carl Otto's saloon and restaurant on Madison Street is depicted in this photo from 1910. The early saloons were usually highly decorative, and the bars were often very ornate. Carl Otto is pictured on the left. The specialty of his restaurant was sauerbraten. (Author's Collection.)

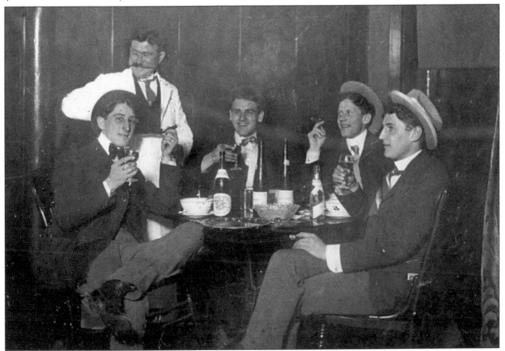

A group of Watertown youths are pictured here out for a spree at one of the local saloons in the early 1910s. (Watertown Historical Society Collection.)

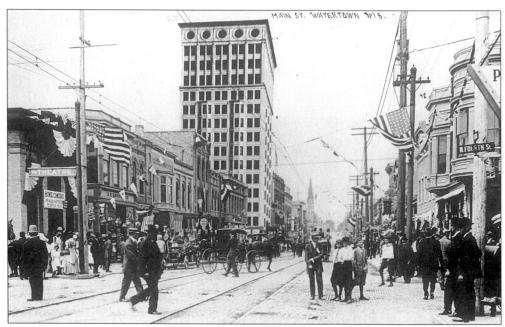

This is an exaggerated photo postcard of Watertown from 1910. These types of photo postcards were often produced to make out-of-town recipients think the city was more prosperous than it really was. (Author's Collection.)

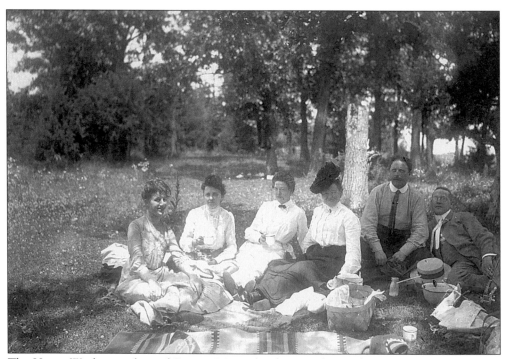

The Henry Winkenwerder and Eugene Meyer families, residents of Watertown, are shown in this photo out for a picnic around the turn of the century. (Watertown Historical Society Collection.)

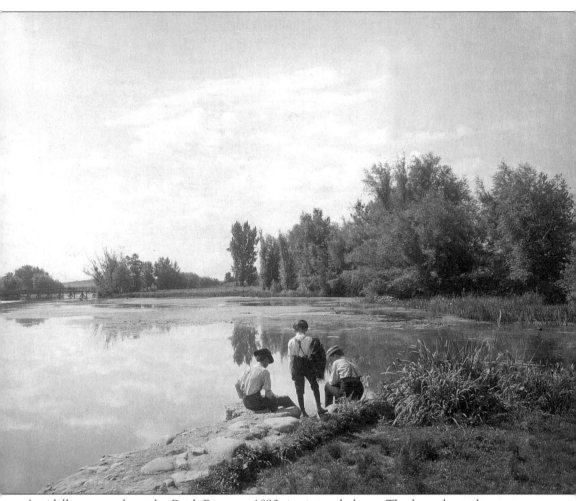

An idyllic scene along the Rock River, c. 1890, is pictured above. The boys shown here are preparing to take a swim in the river below the Oconomowoc Avenue bridge. (Watertown Historical Society Collection.)

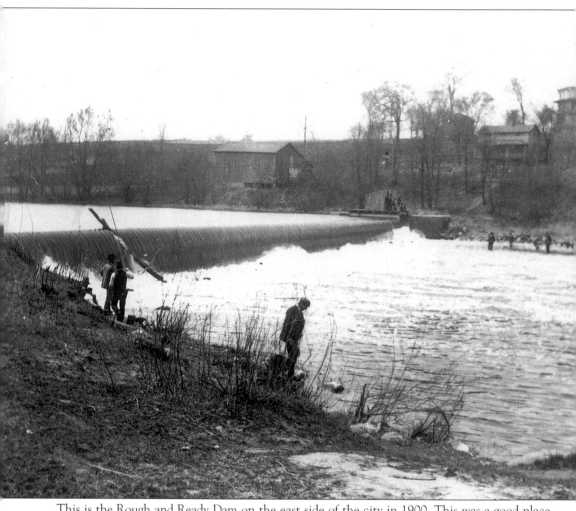

This is the Rough and Ready Dam on the east side of the city in 1900. This was a good place to go fishing. (Krueger Collection.)

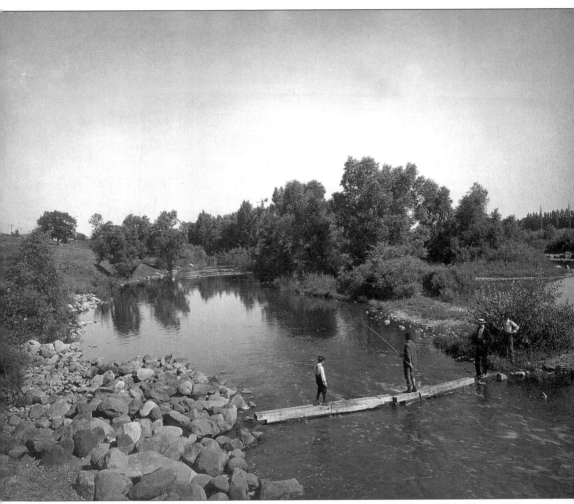

These individuals are pictured walking on logs across the old mill race to Tivoli Island, c. 1890. Historian E.C. Kiessling wrote of the Rock River: "Some miles to the east that lordly stream flows southward and would normally have missed Watertown. But then, as though it had overlooked something precious, it turned back to the north and with a large endearing loop encircled the site of our city before flowing south to the Mississippi." (Watertown Historical Society Collection.)

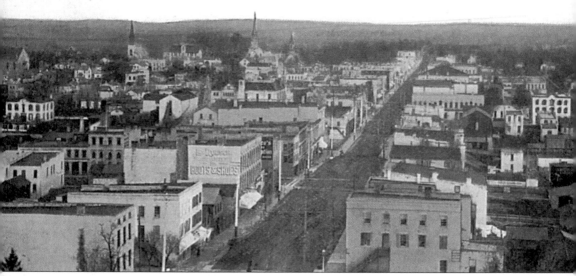

Bird's-eye View, Watertown, Wis.

This is Watertown, Wisconsin, as it appeared in 1910. A local resident, Ella Wilder, wrote a poem about the city in 1936, which said, in part,

"Mid trees of shimmering green,
With crystal waters in between
And Red Men everywhere,
Up sprang a modest town,
Which since has gained renown
Through those who labored there...."

(Author's Collection.)

EPILOGUE

We end where we began, with the 1936 Centennial celebration. Life comes full circle, as does this book. Therefore, we end with some more sights from the celebration, such as the ladies below.

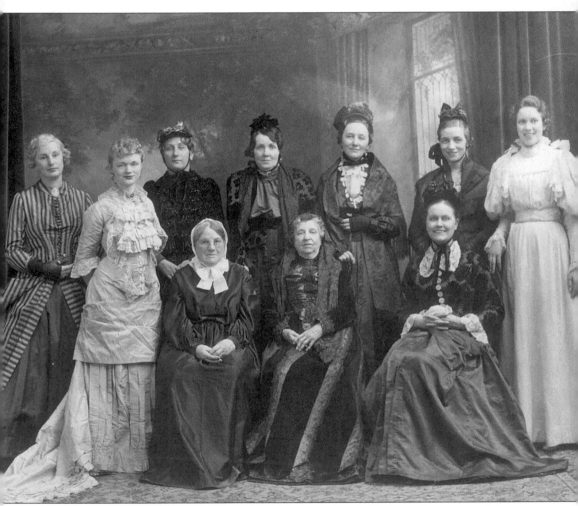

This photo depicts the ladies of the Saturday Club dressed in old fashioned gowns to celebrate the 1936 Centennial. The ladies are, standing from left to right: Mrs. Edgar Miller, Mrs. Charles E. Kading, Miss Gladys Mollart, Mrs. W.S. Waite, Mrs. A.G. Kotchian, Mrs. A.P. Hinkes, and Mrs. Elmer Kiessling. Seated in front, from left to right, are: Miss Ella Wilder, Mrs. S.E. Holmes (Timothy Johnson's granddaughter), and Mrs. Elmer Buegler. (Author's Collection.)

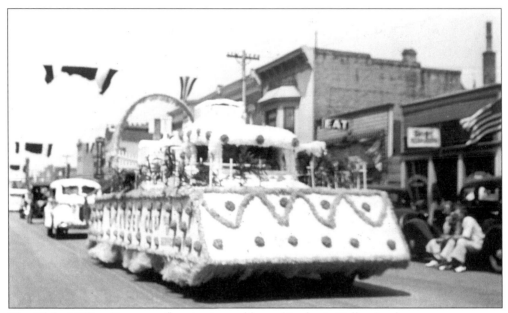

The Globe Milling Company float is pictured here. (Author's Collection.)

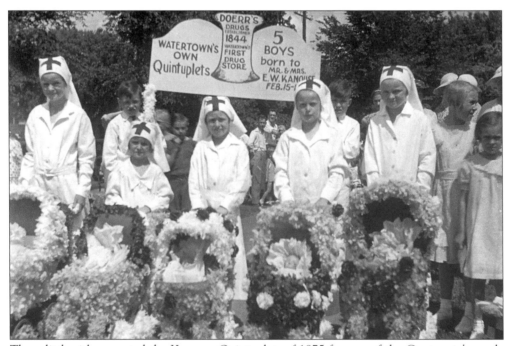

These little girls recreated the Kanouse Quintuplets of 1875 for one of the Centennial parade entries. (Watertown Historical Society Collection.)

ACKNOWLEDGMENTS

The author of this volume would like to thank the following for allowing him access to their collections of views of Watertown:
Frank and Georgianne Lindemann
Robert Krueger
Arline Hildebrandt
Edward Stuebe
Mary Mueller
The Watertown Historical Society
Steve Hady
Bernhard and Eleanore Schroeder

Thanks are also due to the following who lent their support to this project:
James Tobalske
Lloyd Schultz
Co Mo Photo of Watertown
Charles J. Wallman

A special thank you to everyone I may have missed. Your contributions are all greatly appreciated.

Anyone possessing images of Watertown that should be included in future volumes can contact the author by writing to:
William F. Jannke III
1121 Highland Avenue
Apt. 153
Watertown, WI 53098

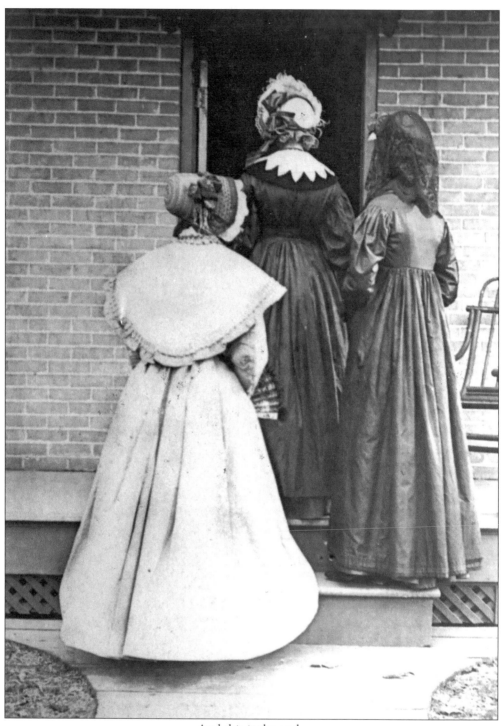

And this is the end.